BIRKENHEAD
THROUGH TIME
Ian Collard

AMBERLEY PUBLISHING

UBI FIDES IBI LUX ET ROBUR

BIRKENHEAD.

First published 2012

Amberley Publishing
The Hill, Stroud
Gloucestershire, GL5 4EP

www.amberley-books.com

Copyright © Ian Collard, 2012

The right of Ian Collard to be identified as the
Author of this work has been asserted in accordance
with the Copyrights, Designs and Patents Act 1988.

ISBN 978 1 84868 965 7

British Library Cataloguing in Publication Data.
A catalogue record for this book is available from
the British Library.

Typeset in 9.5pt on 12pt Celeste.
Typesetting by Amberley Publishing.
Printed in the UK.

Introduction

It is claimed that the name Birkenhead comes from the Norse word *heafod* of the Birken or Birket, a river which flows to Wallasey Pool. However, others feel that it comes from Anglo-Saxon for a promontory of the birches; it is known that this part of the Wirral was densely wooded.

The first recorded inhabitants of Birkenhead were Benedictine monks who established a priory next to a landing stage on the river at Woodside. In a charter of 13 April 1330, Edward III granted the Prior and Priory of Birkenhead and their successors forever the passage over the arm of the sea and the right to make reasonable charges.

In the sixteenth and seventeenth centuries, there were various disputes between the burgesses of Liverpool and the owners of the Woodside ferry. By 1762, a coach ran from Woodside to Chester and Parkgate three days a week. In 1801 there were 110 people living in Birkenhead; the area fronting onto the river was developed with the construction of housing. Improved services from Liverpool to the Wirral encouraged people to move to Birkenhead; the population of 200 in 1821 had doubled by 1823.

William Laird had moved to Liverpool in 1810 to help attract orders for his father's rope works in Greenock. He was initially interested in a scheme to sail ships up the River Dee and cross the peninsula by canal to Birkenhead but the scheme was abandoned. The Great Western Railway and the London & North Western Railway were interested in access to the Mersey docks. Sir John Tobin and John Askew purchased land and asked Thomas Telford to look at the possibility of building a port on the Wirral side of the river. An Edinburgh architect, Gillespie Graham, was appointed by William Laird in 1826 to design and build Hamilton Square and the surrounding roads and buildings.

In 1831 the census showed 2,569 inhabitants in Birkenhead and on 10 June 1833, Royal Assent was given to an Act of Parliament for 'paving,

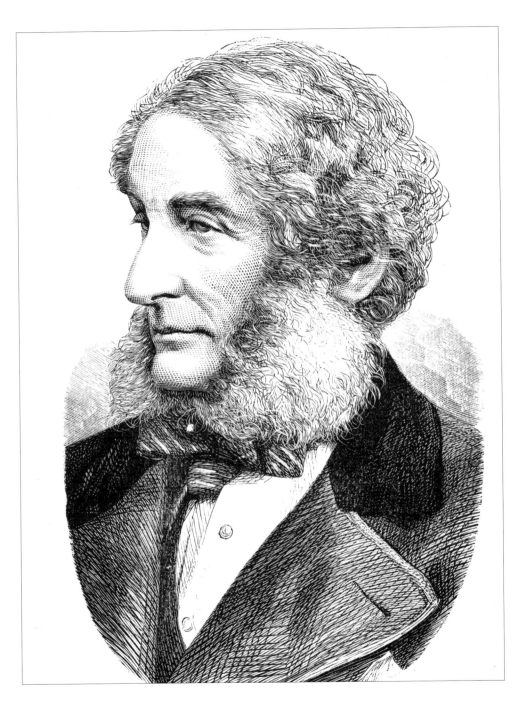

John Laird.

lighting, watching, cleansing and otherwise improving the Township of Birkenhead, and for regulating the Police and the establishment of a Market'. Improvement Commissioners were then appointed.

Work on the Chester & Birkenhead Railway was started in 1838, a single line opening in September 1840. In 1842 the Improvement Commissioners took over responsibility for the Woodside ferry, and the following year they drew up plans for a dock system at Birkenhead. The foundation stone was laid on 23 October 1844. That same day, Monks Ferry Station was opened, giving a direct rail link to Liverpool. Egerton and Morpeth Docks were opened on 5 April 1847, followed by the Great Float, later divided into East and West Floats. Following complaints about the high cost of shipping goods through the Port of Liverpool, the Mersey Docks & Harbour Board took over the operation of the docks at Liverpool and Birkenhead.

Birkenhead Park was designed by Joseph Paxton and opened on 5 April 1847. Birkenhead was the first town to ask Parliament for the powers to build a park and the opening was attended by over 10,000 people. In 1850 the American landscape architect Frederick Law Olmsted visited the park and it influenced his design for Central Park in New York. He described Birkenhead as 'a model town', built 'all in accordance with the advanced science, taste, and enterprising spirit that are supposed to distinguish the nineteenth century'.

In 1850, the Birkenhead Street Tramway, from Woodside Ferry to Birkenhead Park, was the first in Europe. Birkenhead became a Parliamentary Borough in 1861 and John Laird became the town's first MP in 1863. A petition requesting a Charter of Incorporation was granted on 13 August 1877; the first election for the new council took place on 14 November 1877. In 1888, the town was made a County Borough.

The rail passenger service was transferred from Monks Ferry to Woodside Station in 1878 and a new line was opened from Hoylake to the Dock Station at the Great Float. The Wrexham, Mold & Connahs Quay Railway joined with the Manchester, Sheffield & Lincolnshire Railway in 1896, providing a link from the main line.

Cattle were one of the main cargoes handled at Birkenhead; in 1879 sheds incorporating cattle pens were constructed at Morpeth Dock. Slaughter houses and cooling rooms were built but at the beginning of the twentieth century the trade was reduced by the introduction of cold storage on ships.

By 1887 the official population of the Borough was 84,006, with 7,696 houses.

Mrs W. H. Lever performed the ceremony of cutting the first sod at Port Sunlight on 3 March 1888, following the decision to move

production of Sunlight soap from Warrington. Lever Brothers was founded by William Hesketh Lever; he leased a factory in 1886 and went into partnership with his brother. Lever was created a baronet in 1911 and a baron in 1917, taking the maiden name of his late wife Elizabeth Hulme to form the title Leverhulme.

The tramway had made Birkenhead a pioneer in street traction, and the Corporation were soon adopting the electric system. A scheme was submitted and in 1901 the first electric tramcar was run from Claughton to Woodside ferry.

Between 1870 and 1900, Lairds built 270 vessels. However, Lairds were increasingly unsuccessful in tendering for large cargo vessels and passenger liners. It was apparent that an ambitious programme of expansion and reconstruction was required to enable the yard to compete, and this was initiated in 1900.

In 1903 the Sheffield firm of Charles Cammell joined with Lairds. Charles Cammell had founded the firm to produce railway equipment such as rails, switches, and carriage wheels; by 1861 it was producing armour plating which Lairds used in the building of naval vessels. The merged concern was named Cammell Laird & Company Limited.

In 1902 the Wirral and Birkenhead Agricultural Society held their diamond jubilee show at Bebington and it proved to be one of the major attractions in the Borough that year; in 1903 the Birkenhead Unitarian Church was erected in Bessborough Road; the Mersey Railway ran the first electric train through the tunnel from Liverpool; and the new wing of the Wirral and Birkenhead Children's Hospital was opened. However, in 1909, during the construction of Vittoria Dock, there was a disaster when the dam collapsed, resulting in fourteen deaths.

In 1912, Joseph Rank built a large mill on the quayside in the West Float, followed by others over the following years. Grain was transferred directly from ships to the mills, where it was processed. In 1937 the milling trade led the way in giving to the workforce engaged in the industry a guaranteed working week.

In 1912 the Earl of Derby opened the Art Gallery and Museum and the Arno Recreational Ground was presented to the Borough by the Earl of Shrewsbury. A new Infirmary of the Tranmere Workhouse was built in 1913.

Following the First World War, there was a boom in shipbuilding and the shipyard at Birkenhead was very busy, productive and profitable. However, by 1921 a reduction in freight cargo rates and a disarmament conference had taken their toll. The yard was allowed to complete construction of HMS *Rodney* and managed to obtain some orders for merchant vessels.

A disagreement over the entrances to the Mersey Tunnel was resolved in April 1927 and the Queensway road tunnel was opened by King George V on 18 July 1934. However, by the early 1960s traffic had increased dramatically and plans were drawn up for the construction of another tunnel. Work began in 1966 and the first tube of the new tunnel was opened by Her Majesty the Queen on 24 June 1971.

During the Second World War, Cammell Laird completed repairs on 120 warships, including nine battleships and eleven aircraft carriers, and 2,000 merchant vessels. They built 106 naval vessels, averaging one ship delivered every twenty days. At the end of hostilities, the yard changed production to merchant vessels; the major British shipping lines had lost many of their vessels during the war and were embarking on dramatic replacement programmes.

Chemicals and minerals were imported and factories set up around the dock estate. Iron ore was imported through Birkenhead for onward shipment to steel works in North Wales; by 1954 the iron ore trade had increased to one million tons and by 1956 it had doubled. The Vacuum Oil Company imported crude oil to their works near the docks and processed and blended it.

In 1957, Cammell Laird announced a reconstruction programme that involved building large prefabricated units in new shipbuilding shops. Plans were also announced for a new dry dock to accommodate large tankers. When Princess Alexandra opened the new Princess dry dock in 1962, it was the largest privately owned dry dock in Britain.

The Local Government Act 1972 created the Metropolitan Borough of Wirral by merging Birkenhead with Wallasey, Bebington and Hoylake. In 1977 Cammell Laird was nationalised, becoming part of British Shipbuilders until 1985, when it was denationalised and became a subsidiary of Vickers Shipbuilding & Engineering Limited. The collapse of the Soviet Union brought a significant reduction in Admiralty orders and Cammell Laird decided to change its status to a mixed yard, so it could tender for commercial contracts and apply for European Union grants for aid. By 1993 Vickers decided that it would not be seeking orders for the Birkenhead yard and it was closed that year, ceasing to trade as Cammell Laird on 30 July.

However, by 1995 new owners had re-opened the yard under the name of Cammell Laird Group Holdings PLC. Despite a strong start, Cammell Laird shares were suspended on the Stock Exchange after the loss of a major order. On 17 August 2001, the yard was bought for almost £10 million by ship repair company A&P. The chief executive said that there were not enough contracts to fill the two yards he already owned, let alone re-open Cammell Laird's three yards.

Following the opening of the new Royal Seaforth Dock in 1970, many of the items shipped through Birkenhead Docks were transferred to the new specialist facilities in Liverpool. However, a new roll-on/roll-off terminal was built, providing facilities for passengers and cargo services to Belfast, Dublin and Douglas, Isle of Man.

The Mersey Docks & Harbour Company was acquired in 2005 by Peel Ports, who stated that they were committed to give priority towards the redevelopment and regeneration of the Liverpool & Birkenhead Dock Estate. Consequently, in September 2006 they announced plans for possibly the largest regeneration scheme in the country, called Wirral Waters. A new retail and leisure quarter will be developed, incorporating green measures such as cycle and pedestrian routes. The East Float and Vittoria Dock will form the main section of the new buildings, linked by pedestrian bridges to retail and leisure developments.

At the beginning of 2007, it was announced that Peel Holdings PLC had bought the Birkenhead shipyard. The shipyard would continue to provide ship repair and conversion facilities under the auspices of North Western Shiprepairers Limited, in which Peel had a major holding and which was renamed Cammell Laird Shiprepairers & Shipbuilders Limited. In January 2010, Cammell Laird secured a contract to build the flight deck for the new aircraft carrier HMS *Queen Elizabeth*. The vessels are the biggest and most powerful warships ever built for the Royal Navy and will enable Birkenhead to secure its place as one of the major shipbuilding and ship repair centres in the United Kingdom.

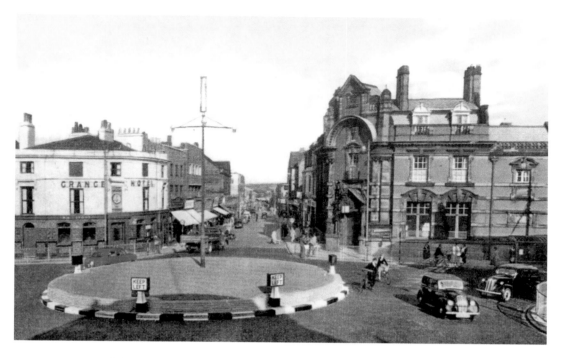

Grange Road from Charing Cross

The Birkenhead Brewery public house, the Grange Hotel, was built in 1840. The pub was closed in 1982 and demolished and is now the site of a fast food restaurant. Martins Bank, later Midland Bank, was built in 1901 and has now been converted into a bar. The roundabout has now vanished, being replaced by traffic lights.

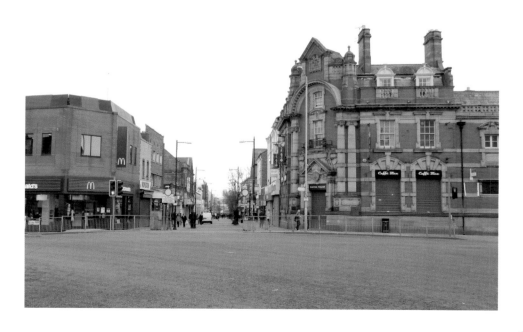

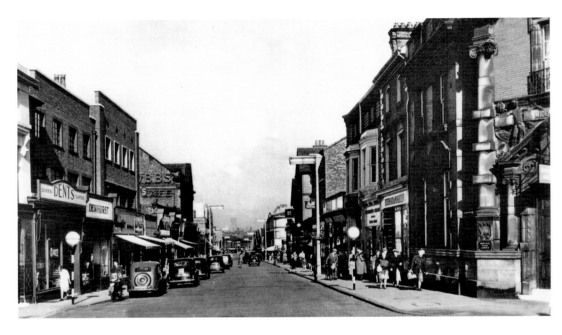

Grange Road From Charing Cross

Looking down Grange Road from Charing Cross. The buildings at this end of the main shopping street have changed little apart from the construction of a branch of a major supermarket in 2011. The whole length of Grange Road has now been pedestrianised and has been traffic-free for some years. A large multi-storey car park has now been constructed to the rear of the new supermarket to enable customers to park near to the shops in Grange Road.

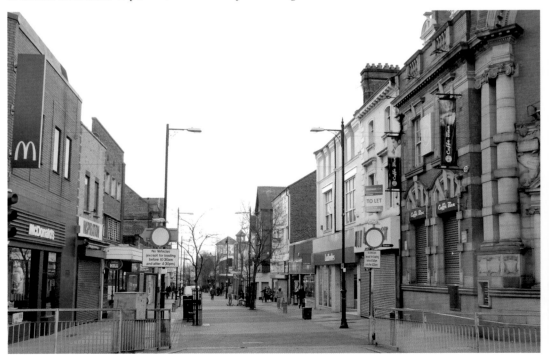

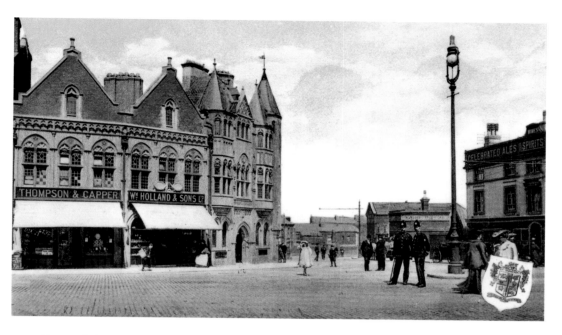

Exmouth Street From Charing Cross

Charing Cross, looking down Exmouth Street in 1907. The building in the centre was originally a branch of the Bank of Liverpool and was built on the site of the Unitarian Chapel. With five roads converging onto Charing Cross, it is one of the busiest junctions in the town.

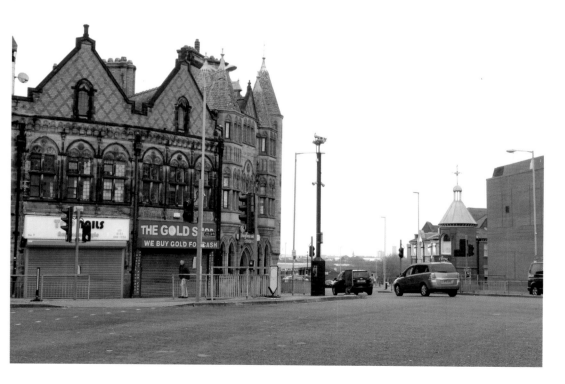

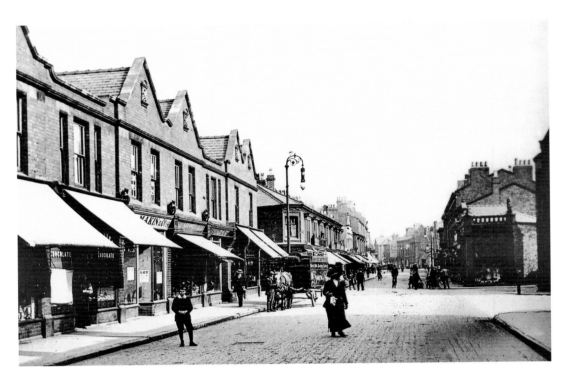

Grange Road West

Grange Road West, looking towards Charing Cross. It was once as popular as Grange Road but in recent years it has become the home of several major banks and building societies.

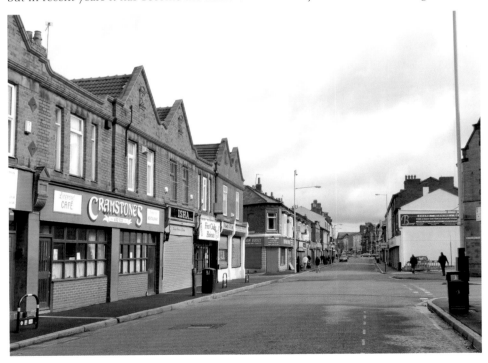

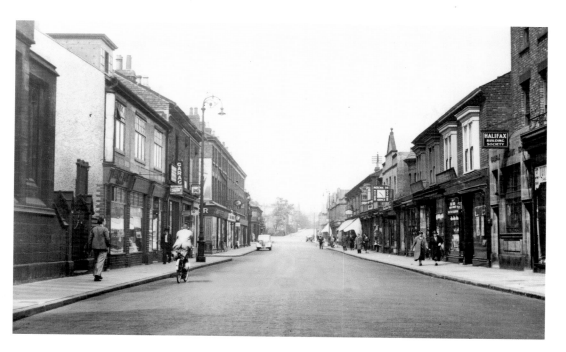

Grange Road West From Charing Cross

A view of Grange Road West from Charing Cross. The Little Theatre in Grange Road West was built as the Grange Road Presbyterian Church of England in 1848 and served as a place of worship for exactly 100 years. The last service took place on 14 July 1948 and the congregation helped to finance a new church at Bebington. The church in Grange Road West was later purchased by the Birkenhead Repertory Theatre Limited.

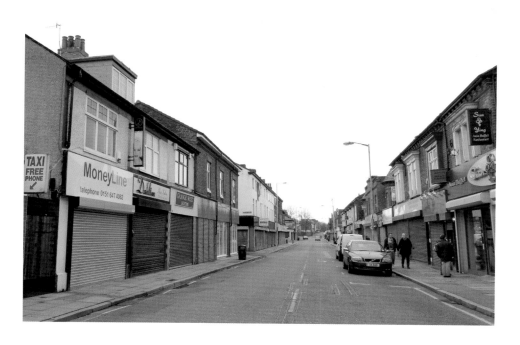

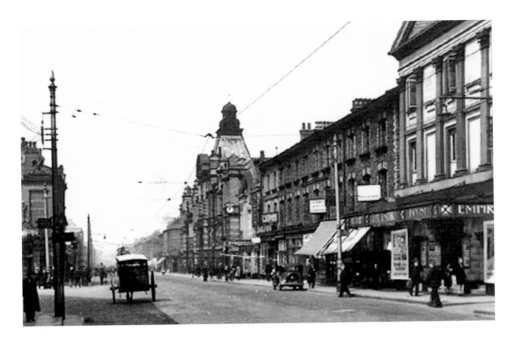

Conway Street

Conway Street *c.* 1930, showing the Conway Arms on the left, which was situated on the corner of Claughton Road. The pub was demolished in the 1960s when the area was redeveloped and the tunnel flyover roads were constructed. The Empire Cinema was the last cinema in Birkenhead when it closed in 1991. The building next to C. Stephens, Funeral Directors, is the main Post Office, which was moved to Argyle Street in 1908. It became The Picture House and later The Super Cinema, and was one of the first venues for The Beatles in the 1960s. It later became a ballroom and furniture showroom and, recently, a restaurant. The building with the dome was the Birkenhead Higher Elementary Technical School.

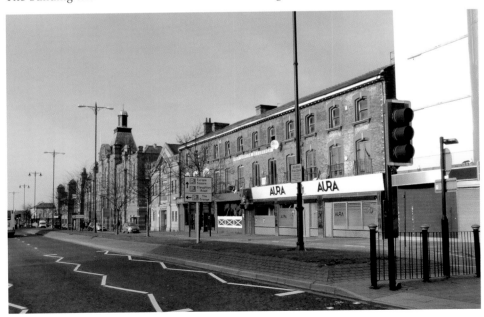

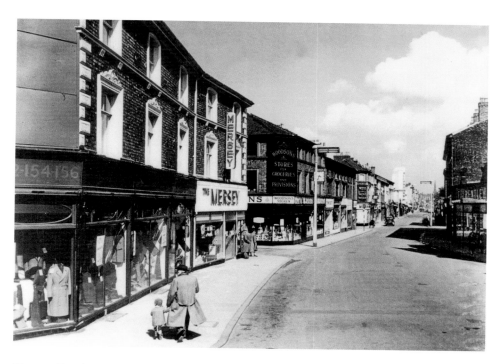

Mersey Furniture, Grange Road

The Mersey furniture shop, next to Woodson's Stores, Groceries and Provisions in Grange Road, on the junction with Milton Street. Allansons, which is now Beatties, can be seen in the distance.

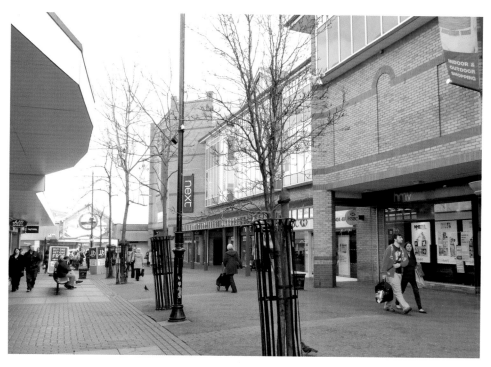

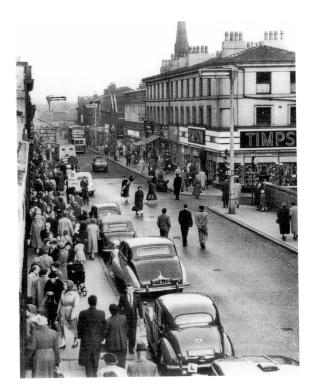

Timpson's, Grange Road
Timpson's shoe shop in Grange Road, opposite the YMCA building, which was opened in 1890 and provided services for young people until it moved to Whetstone Lane in 1934. The first meeting of the Boy Scout Movement took place in this building on 24 January 1908.

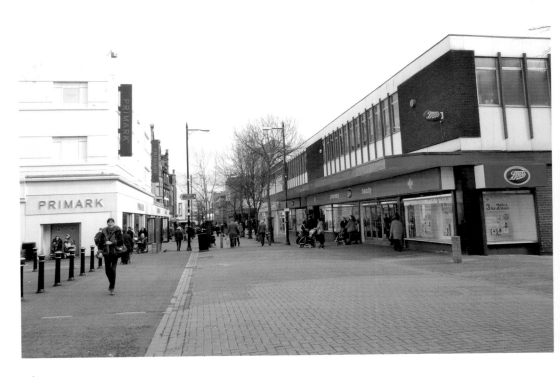

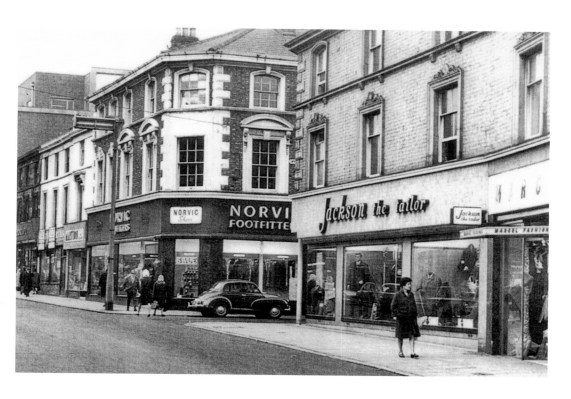

Grange Road, Towards Charing Cross

Looking in the other direction along Grange Road towards Charing Cross. The building originally built as a Cooperative superstore can be seen on the left of both photographs. The building in the bottom photograph is closed and shuttered as the business has recently been transferred to a shopping complex on the outskirts of the town.

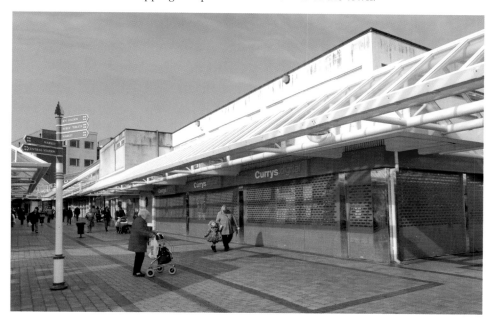

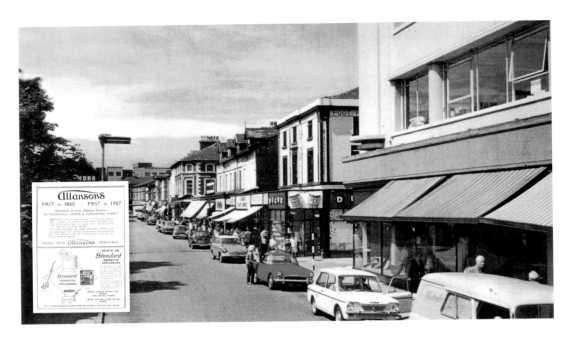

Allanson's, Grange Road

Allanson's department store in Grange Road. The Allanson family opened a draper's shop on the site in the 1860s and the store was developed and enlarged extensively in the 1930s, when it became a public company. The building was damaged by fire during the Second World War and the company was taken over by Beatties in 1964.

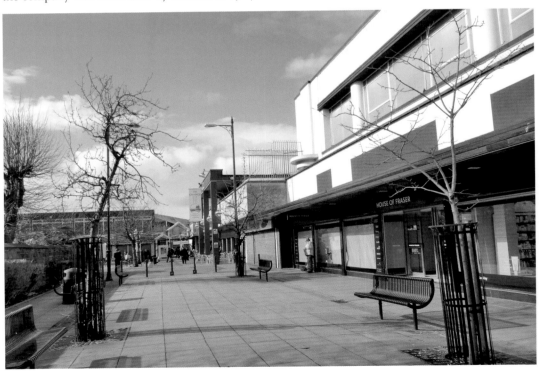

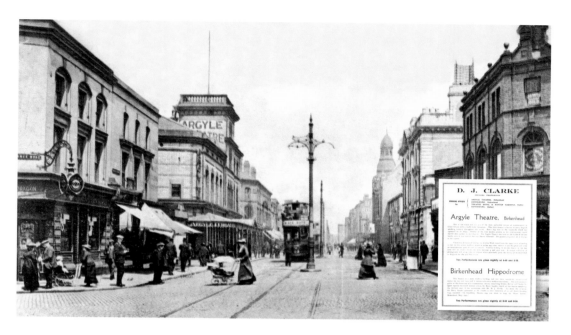

The Argyle Theatre

Argyle Street, looking towards Hamilton Square. The Argyle Theatre was opened on 21 December 1868 by Dennis Grennell, and in 1876 it was renamed the Prince of Wales Theatre. It was managed by Dennis J. Clarke between 1888 and 1934 and the name Argyle was restored. The theatre was destroyed by fire when it was bombed on 21 September 1940.

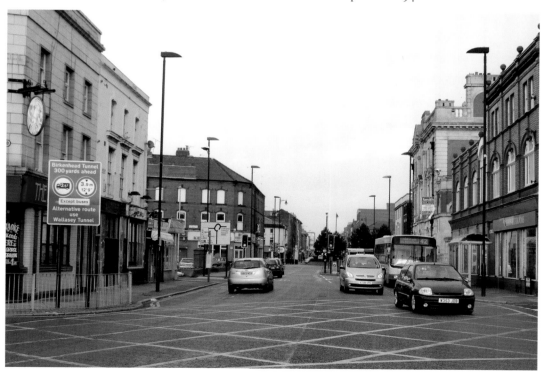

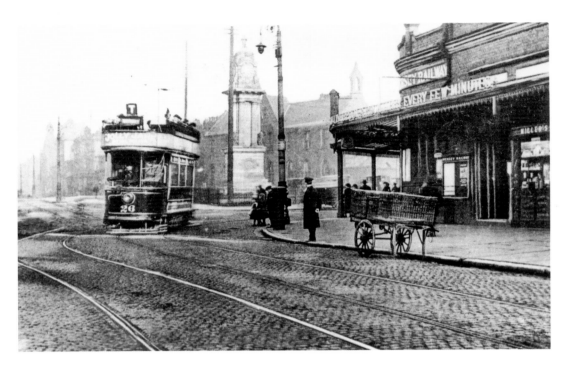

Central Station, Argyle Street

The No. 26 tram passes Central Station, Birkenhead, heading into Argyle Street South. Central Station is on Merseyrail's Liverpool to Rock Ferry and Chester electric railway line.

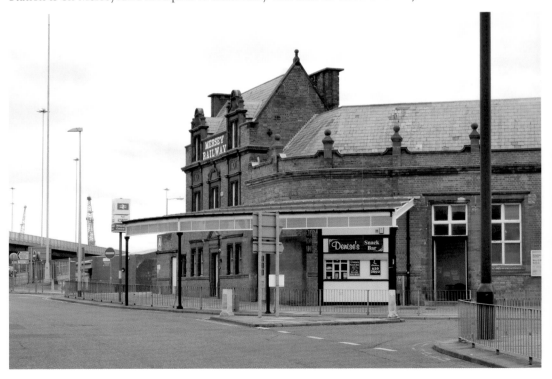

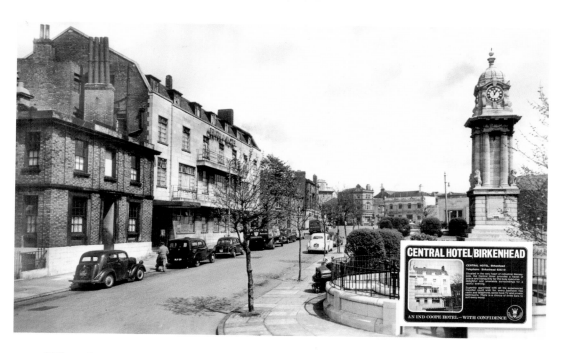

Clifton Crescent

The Central Hotel and the King Edward VII Memorial Clock Tower in Clifton Crescent in 1960. The memorial was unveiled in Argyle Street in 1912 and was moved to its present site in 1929 when work was begun on the construction of the Mersey Tunnel approach roads.

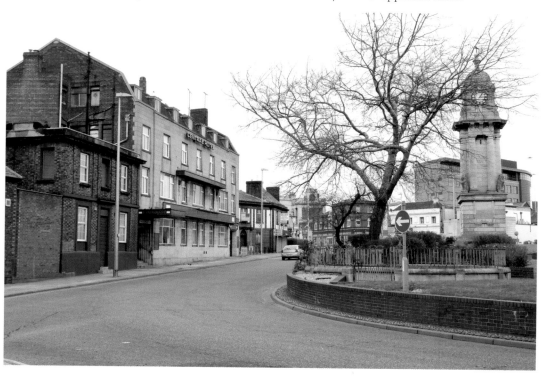

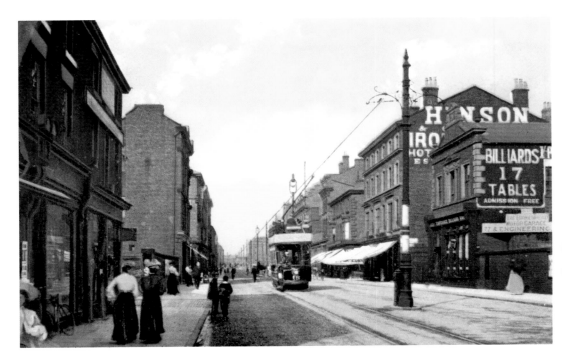

Trams on Argyle Street

A tram travels along Argyle Street towards Central Station in 1908. The line which took all the rail traffic from Birkenhead Docks to the main line travels under the road at this point. The tracks have not been used for several years and are mostly overgrown but there are proposals to open it to rail traffic in the future if finance becomes available.

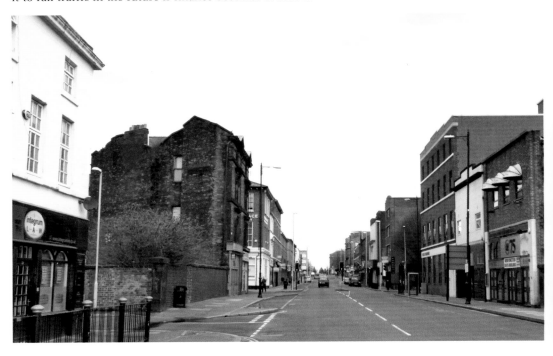

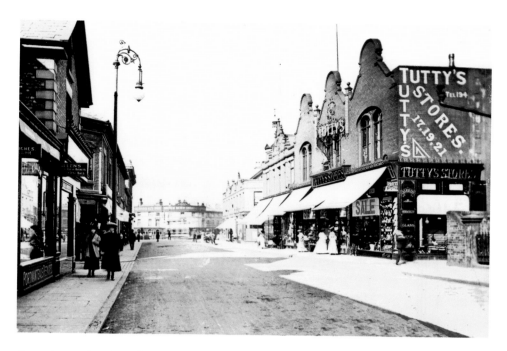

From Oxton Road to Charing Cross

Looking down Oxton Road towards Charing Cross. Tutty's shop at 17 Oxton Road was opened in 1904, and the following year he purchased 19 and 21 Oxton Road and was trading as an ironmonger. He also had chandlery, ironmongery, glass and china shops at 9 Rose Mount, 102a Woodchurch Lane, 176a Bedford Road, 44 Upton Road and 18 Bebington Road. The shop in Oxton Road remained there until 1937, when it was moved to Grange Road West. The Oxton Road premises were taken over by Rostances, who operated there until 1977.

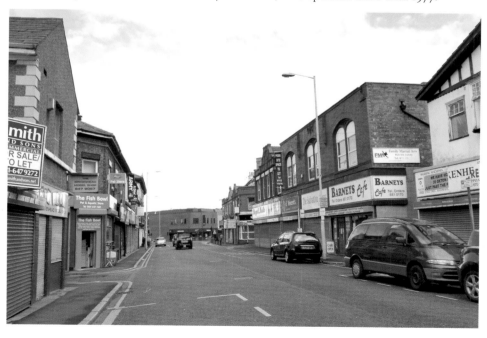

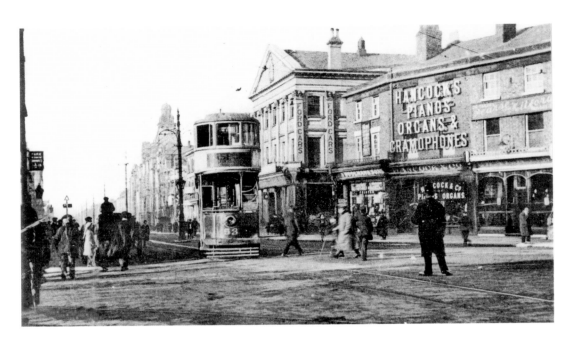

Conway Street

The No. 53 tram turns into Argyle Street from Conway Street in around 1916 as a police officer directs traffic in the middle of the road. In the 1960s a new road was built over this junction to ease traffic congestion caused by vehicles queuing to enter the Queensway Tunnel. The fly-over was later demolished.

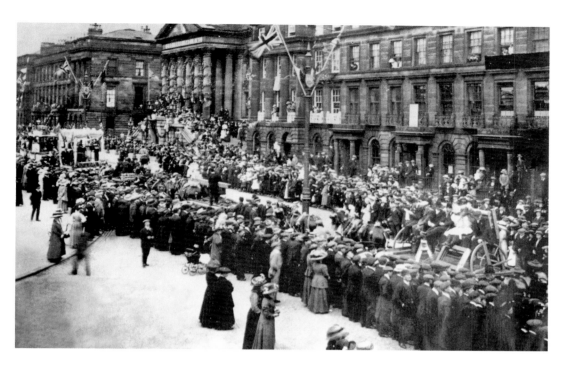

Coronation Day, Birkenhead Town Hall
Celebrations outside Birkenhead Town Hall in Hamilton Square for the Coronation of His Majesty King Edward VII on 9 August, 1902.

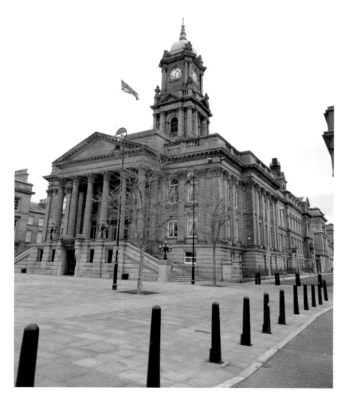

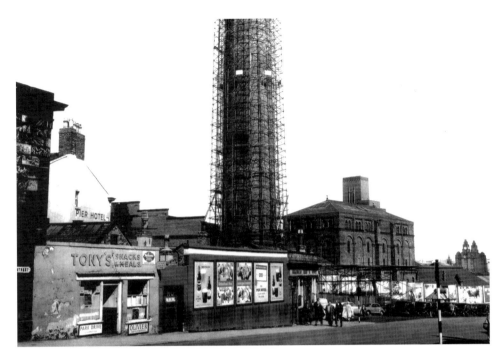

Shore Road Pumping Station

Shore Road Pumping Station at Woodside contains pumps which removed water from the Mersey Railway tunnel under the river. It was built in the 1870s with steam beam engines which were later replaced by electric pumps. One of the original pumps, the 'Giant Grasshopper', is on display at the building, which is now a museum.

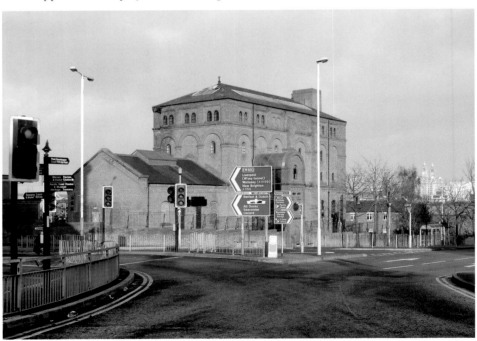

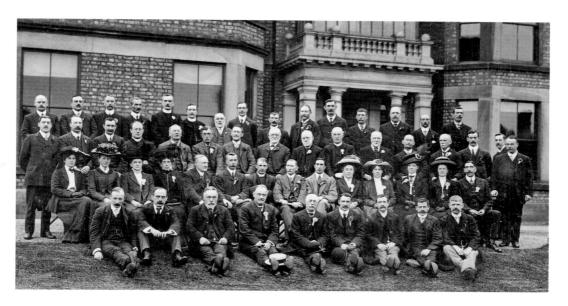

Coronation Day, 1911
The representatives of the Lower Bebington District Coronation Celebrations Committee on 22 June 1911, the day of the Coronation of King George V. Parties, parades and gatherings took place around the town; in New Ferry recruits from the naval training ships marched along New Ferry Road with their bands playing brass instruments.

Birkenhead Electricity
Advertisement for the Birkenhead Corporation Electricity Department.

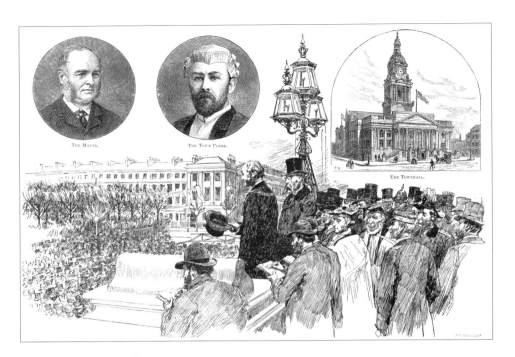

THE MAYOR.

THE TOWN CLERK.

THE TOWNHALL.

Birkenhead Town Hall

The Mayor and Town Clerk address a crowd from the balcony at Birkenhead Town Hall. The foundation stone of the Town Hall was laid by the Mayor, T. S. Deacon, on 10 October 1883 and was opened in 1887. Hamilton Square Gardens were purchased by the Borough in 1903. The original spire of the Town Hall was damaged by fire on 10 July 1901 and was later replaced by a dome. The Cenotaph in front of the Town Hall was unveiled on 5 July 1925 in front of a crowd of thousands of people.

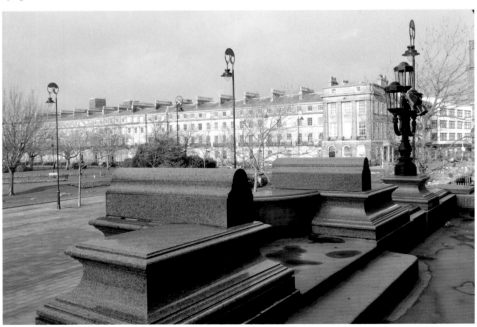

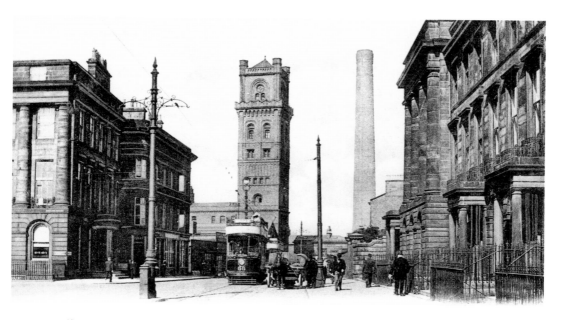

Hamilton Square

Hamilton Square Station, looking towards Woodside. The station is on the Liverpool to New Brighton, West Kirby, Rock Ferry and Chester lines.

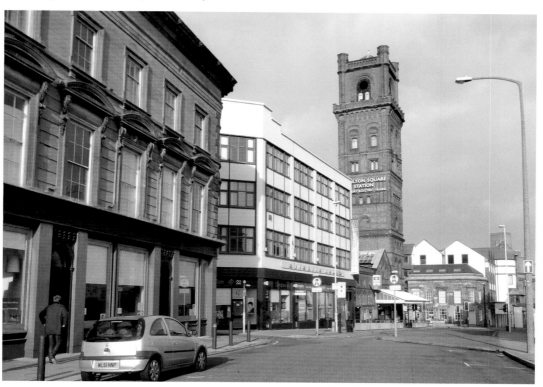

Birkenhead Technical College

Birkenhead Technical College in Borough Road. On 3 May 1950, the day she came to Birkenhead to launch the aircraft carrier HMS *Ark Royal*, Queen Elizabeth, The Queen Mother, laid the foundation stone for the Technical College. The college survived until 2005, when it was demolished and replaced by a housing development.

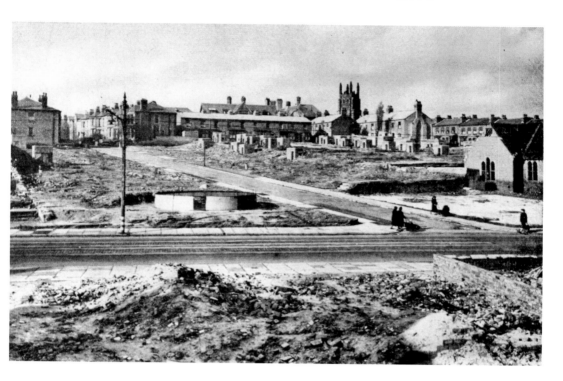

Bomb Damage, Borough Road

Wartime bomb damage in Borough Road. The whole of Merseyside suffered nightly air raids in the early stages of the Second World War. The main target of the bombing was the dock system with its 182 acres of docks and 9 miles of quays. The boroughs of Birkenhead and Wallasey were flanked at either side of the docks and Cammell Laird's shipyard was also a prime target.

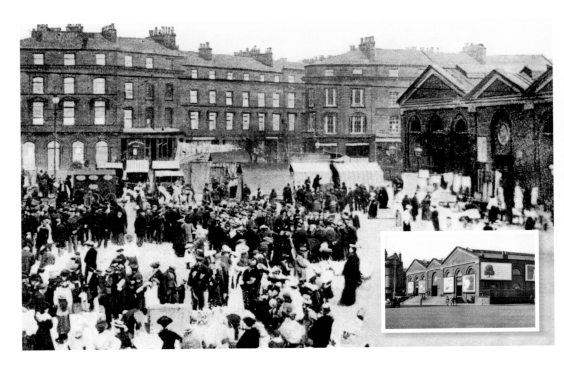

Birkenhead Market

Shoppers outside Birkenhead Market on a Saturday afternoon. The Market Hall was partly destroyed by a serious fire in 1974 and was moved to a new site in Claughton Road three years later. The old market was opened on 11 July 1845 and was built by Fox, Henderson & Company, who also built the Chrystal Palace in London six years later, in 1851. The movement from the original market clock was saved following the fire in 1974 and was restored and incorporated into the new market building.

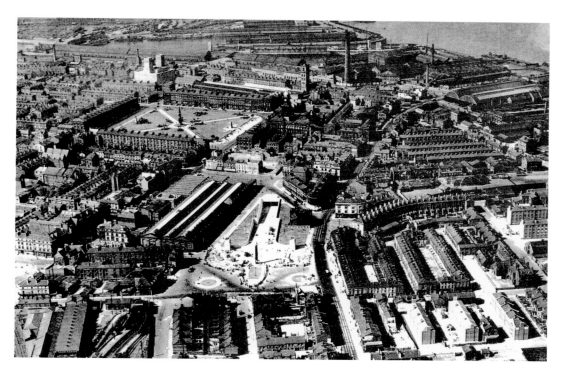

Central Birkenhead

An aerial view of central Birkenhead in 1933 prior to the opening of the Mersey Tunnel the following year. The network of new roads and flyovers which were built in the town in the 1960s can be seen on the bottom photograph.

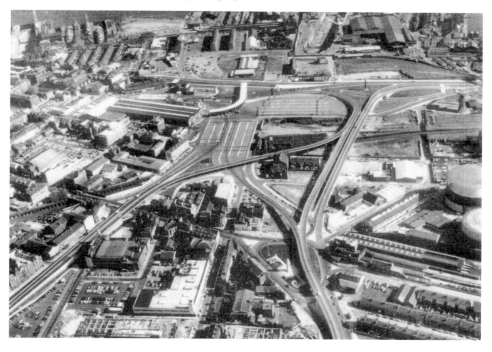

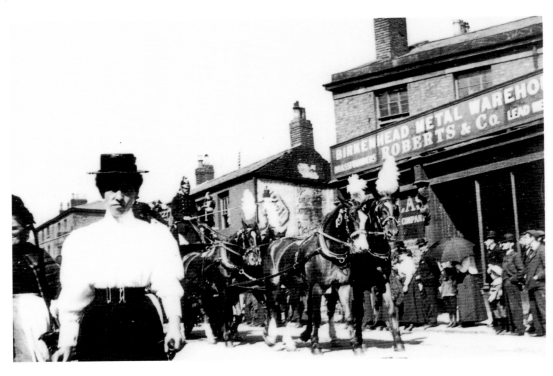

Roberts & Co., Argyle Street
A horse-drawn Birkenhead Fire Brigade vehicle in a parade passing Roberts & Company, Plumbers and Builders' Merchants, in Argyle Street.

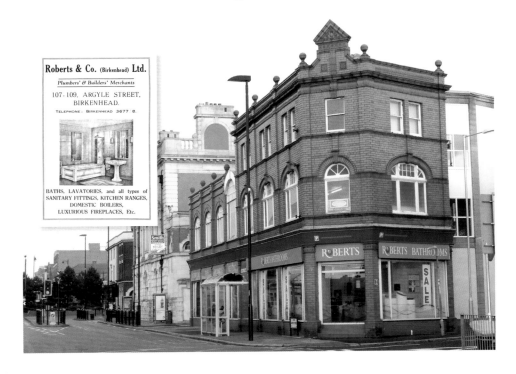

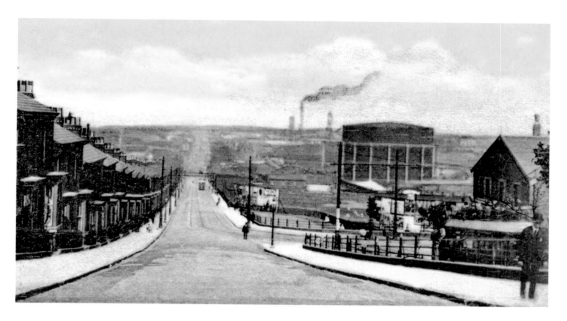

From Argyle Street to Hamilton Square
A view looking down Argyle Street South towards Hamilton Square in 1908.

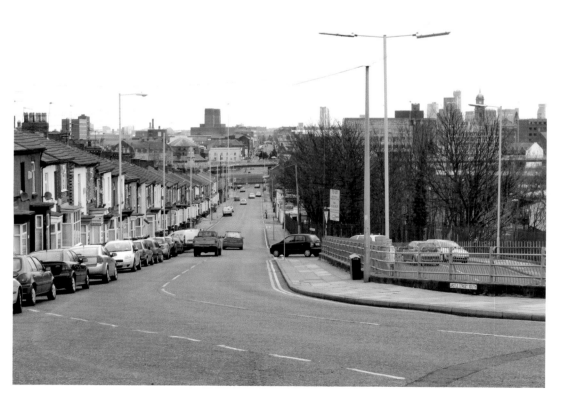

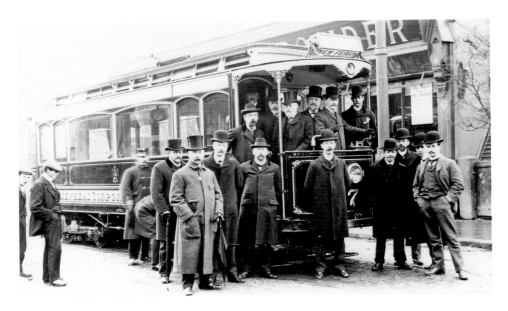

Birkenhead's Trams

The first electric tram to New Ferry was inspected by Board of Trade representatives on 31 January 1901. The service from Brandon Street commenced on 4 February as the track down to Woodside was not completed until 6 June that year. However, because of the low bridge in Chester Street, cars nos 1–13 were single-deck vehicles. The vehicles were converted to double-deck cars, with reduced headroom on the top deck, and introduced into service in 1910. Buses were placed on this route in 1930 and the tram service closed at the end of the following year.

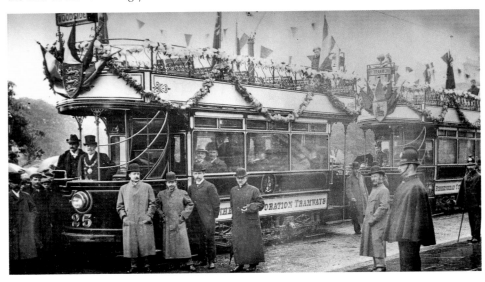

The formal opening of the Town Routes, with Car 25 leading a procession of four decorated cars on 14 August 1901. The photograph is of the official opening ceremony of the Higher Tranmere, Palm Grove via Claughton Road and Claughton Village via Conway Street route. The Prenton and Shrewsbury Road via Borough Road route was opened later that year and the Shrewsbury Road to Upton Road route the following year.

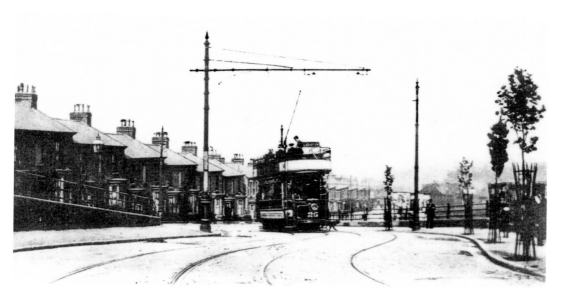

Pearson Road, Tranmere
Birkenhead Corporation tram No. 25 navigates the steep hill in Pearson Road, Higher Tranmere.
Pearson Road is one of the highest points in the town and overlooks the shipways and main
construction sheds at Cammel Laird's shipyard.

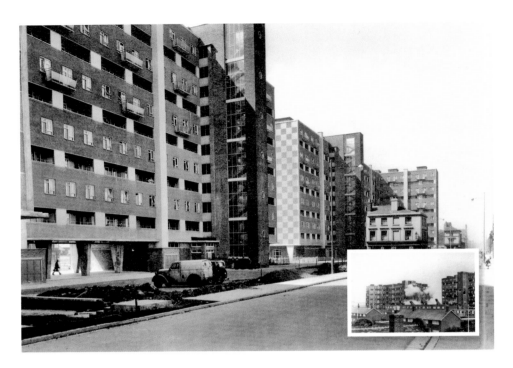

Oak and Eldon Gardens

Oak and Eldon Gardens were opened on 21 April 1958 as Birkenhead's first multi-story flats. However, they proved very unpopular with residents and a decision was made to move people to other properties. The flats were demolished by explosion on 30 September 1979.

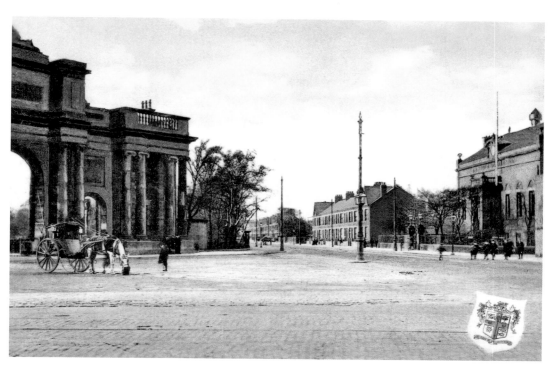

The Park and the Laird School of Art

A horse-drawn carriage at the Park Entrance in 1907. The Laird School of Art stands opposite the Park Entrance. It was given to Birkenhead by John Laird and was opened on 27 September 1871; it was part of The Wirral College of Art and Design for some time.

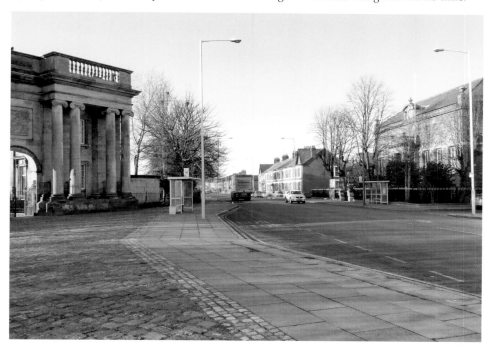

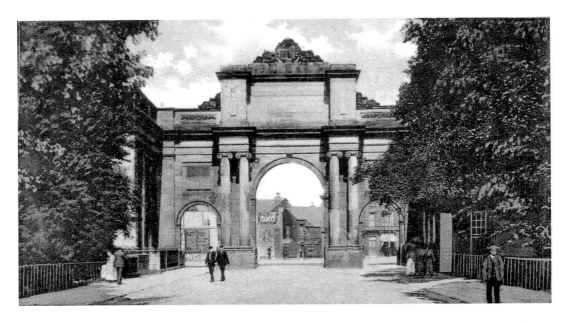

Birkenhead Park Entrance

The Park Entrance was designed by Lewis Hornblower and is situated on the junction between Park Road North and Park Road East. The frontage measures 125 feet, with a central carriageway through an arch of 18 feet span which is 43 feet in height. The original gates featured the armorial bearings of Birkenhead Priory.

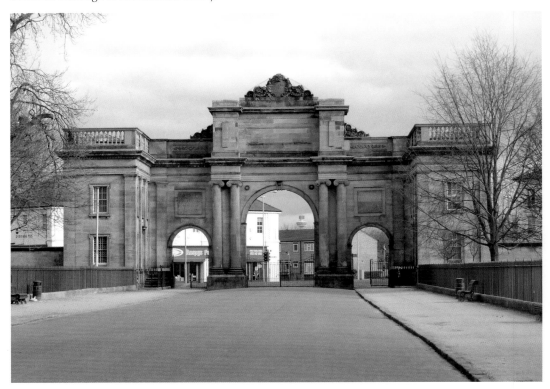

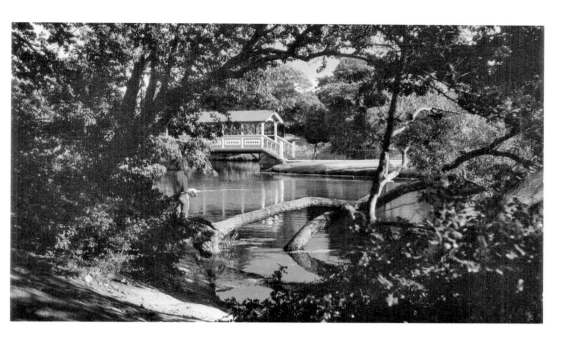

The Swiss Bridge, Birkenhead Park

The Swiss Bridge in Birkenhead Park in the 1950s. The Swiss Bridge, a 23-foot pedestrian span of stringer construction built in 1847, is the only 'covered bridge' of traditional wooden construction (similar to North American and European covered bridges) in the United Kingdom. It was modelled after similar wooden bridges in Switzerland. It was subjected to vandalism for several years and was restored and painted in its original colours in 2008, with help and assistance from the National lottery Heritage Fund.

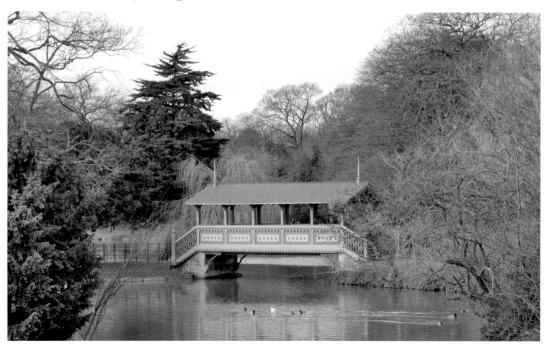

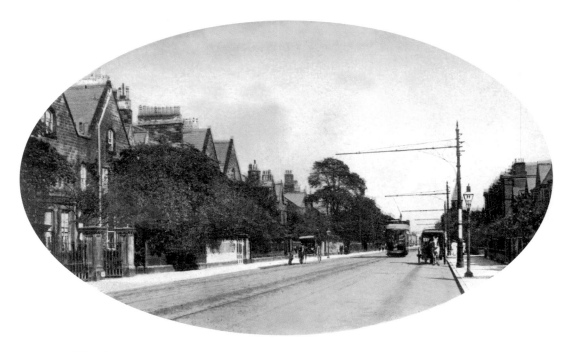

Park Road South

Park Road South in 1911. The church on the right was the Catholic Apostolic Church, built in 1875 and purchased by the Church of Christ and opened on 12 May 1951. It was destroyed by a serious fire in June 2009.

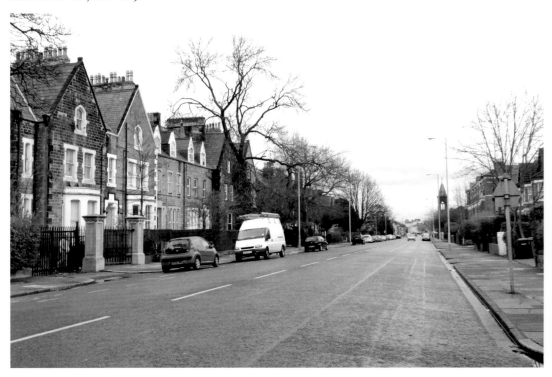

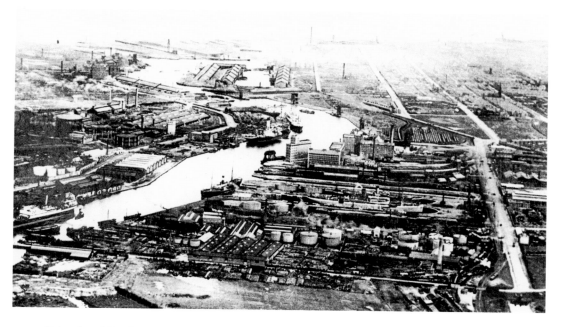

Birkenhead Docks

The Birkenhead Dock system from the air. The revolution in the transport of goods by sea in the 1960s and the introduction of containers meant the withdrawal of most conventional cargo vessels which traded from Birkenhead. The ships that carried the containers became larger to be more cost effective and required specialist facilities and berths. The Royal Seaforth Dock and container terminal also included a grain terminal, which eventually took all of this important trade away from Birkenhead Docks. However, there are still several operational berths in the dock system, which continue to be used by shipping operators and their customers.

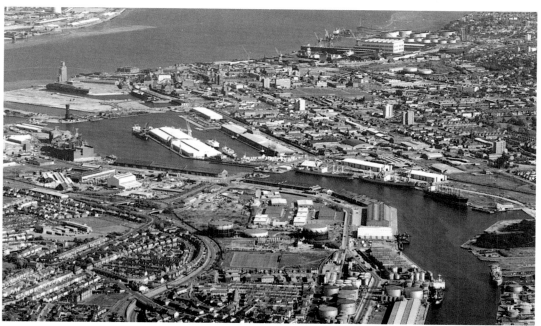

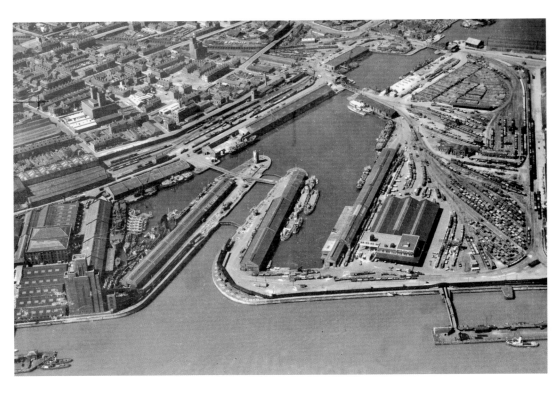

Alfred Dock and Morpeth Dock
The main entrances to the Birkenhead Dock system, at Morpeth Dock and Alfred Dock.

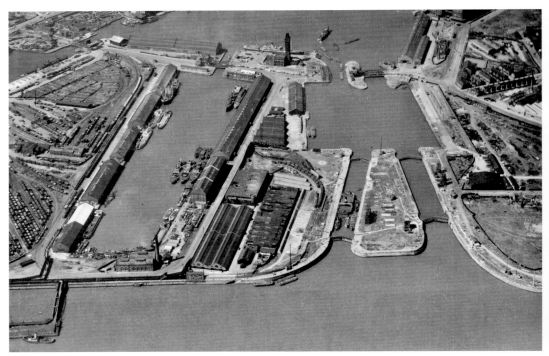

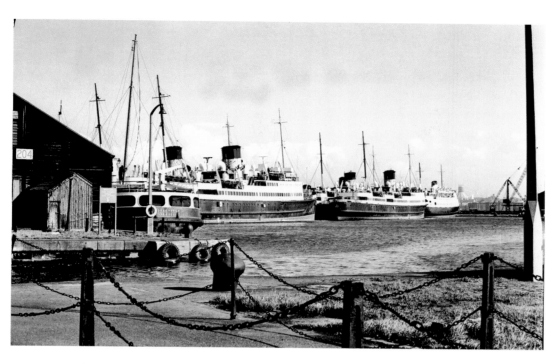

Morpeth Dock

Morpeth Dock, Birkenhead in 1968, with five steamers of the Isle of Man Steam Packet laid up for the winter; they are berthed in front of the Birkenhead Corporation ferry *Woodchurch*. The Isle of Man vessels were usually berthed at Morpeth Dock from September each year to April/May the following year.

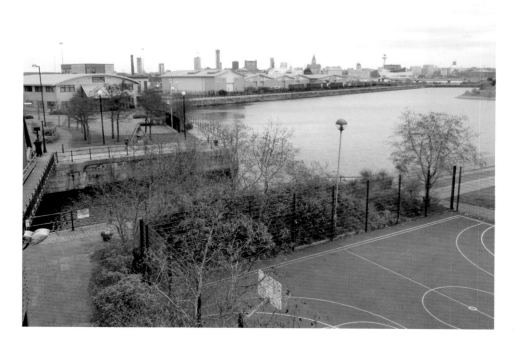

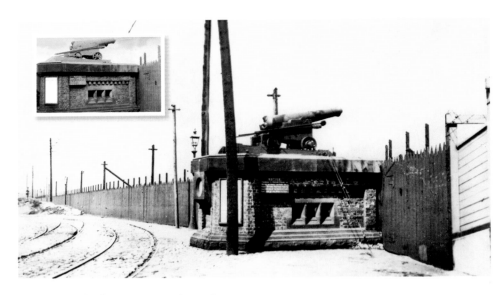

The One o'Clock Gun, Morpeth Dock

The One o'Clock Gun on the river front at Morpeth Dock in 1913. The gun was fired by remote control each working day from Liverpool University's Tidal Institute at Bidston Hill. It operated from 21 September 1867 until 18 July 1969, apart from a break during the Second World War. There was speculation in 1932 that the service would cease. However, following a public outcry a new 32-pounder was provided by Woolwich Arsenal, which arrived on 26 April 1933. Following the Second World War, a third cannon was provided. The six-pounder Hotchkiss naval anti-aircraft gun was fired for the first time on 17 June 1946.

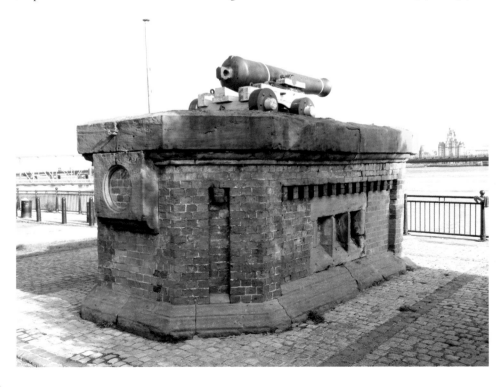

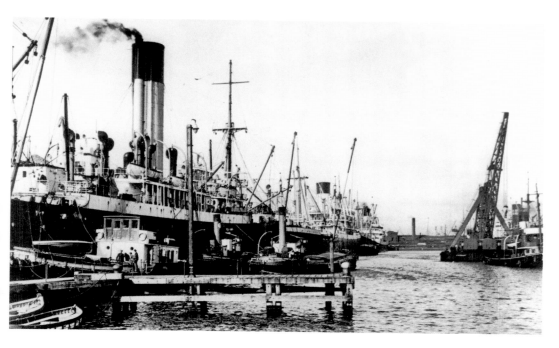

Vittoria Dock
Ships of the Blue Funnel Line loading cargo for the Far East and Japan at Vittoria Dock in the 1950s. The dock is now occupied by vessels which are laid up and are awaiting sale for further trading or disposal to the shipbreakers.

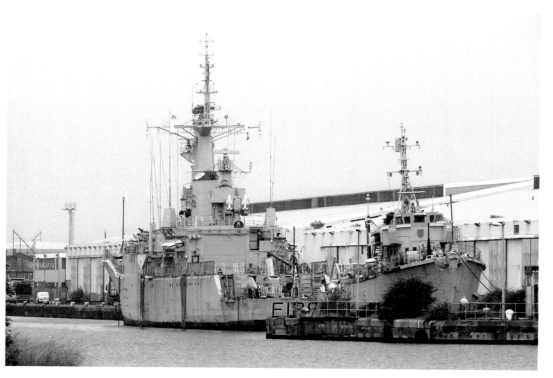

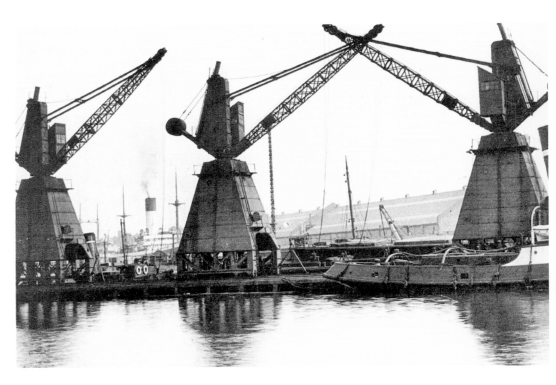

The East Float
Rea's coal berth at Cavendish Wharf in the East Float.

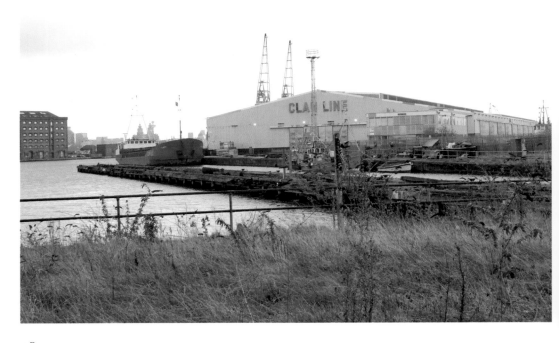

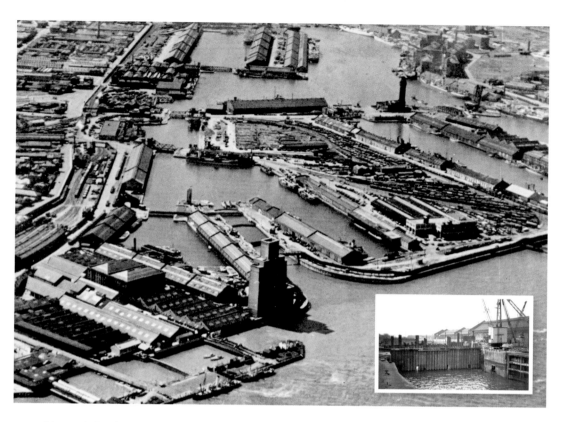

Morpeth Dock

Morpeth Dock entrance. The dock was named after Lord Morpeth, the 7th Earl of Carlisle, who was the first Commissioner of Woods and Forests. The locks giving access to the River Mersey have been removed, as has the access to the East Float via Egerton Dock. The branch dock has also been filled in to provide land for a water treatment plant.

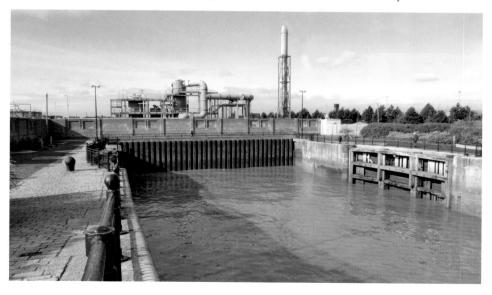

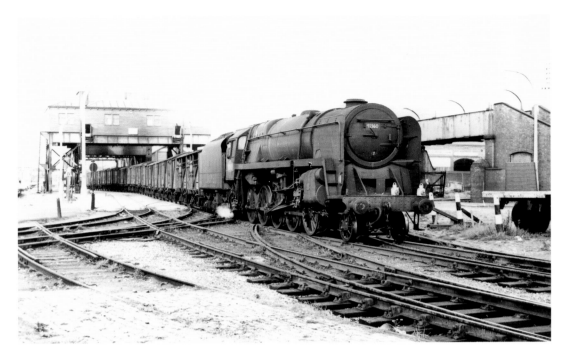

Egerton Bridge

Locomotive 92160 leads a train over Egerton Bridge on 9 September 1966. The tram which can be seen where the railway line once stood operates from Woodside to the tram depot in Taylor Street as a tourist attraction at weekends.

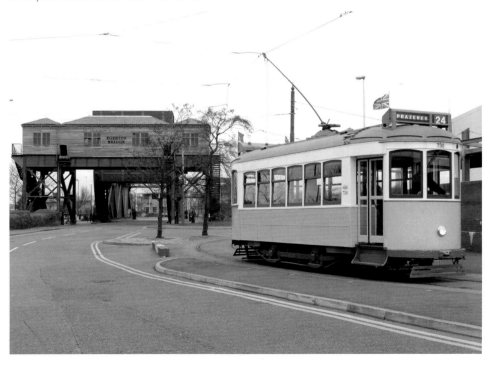

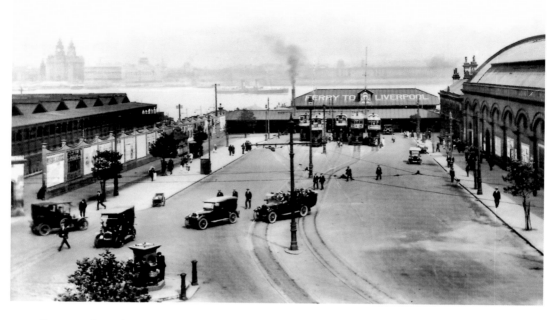

Buses and Ferries at Woodside

Woodside Bus Station and Ferry Headquarters. For many years this was the main bus, rail and ferry terminus in the town.

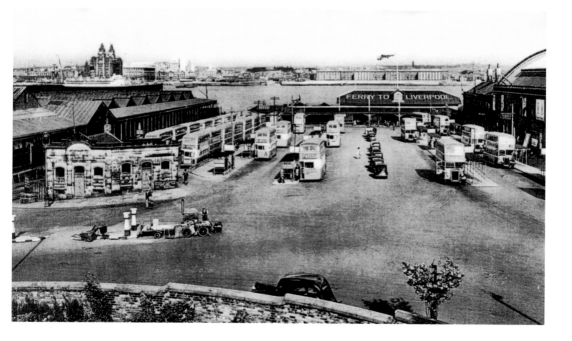

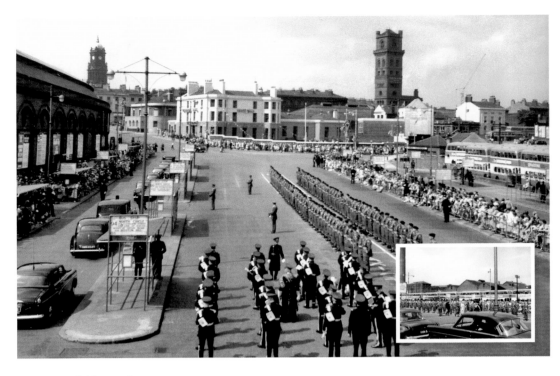

Woodside Station

HM Queen Elizabeth, the Queen Mother, arrives at Woodside Station prior to travelling to Cammell Laird's yard to launch the Union Castle passenger liner *Windsor Castle* on 23 June 1959.

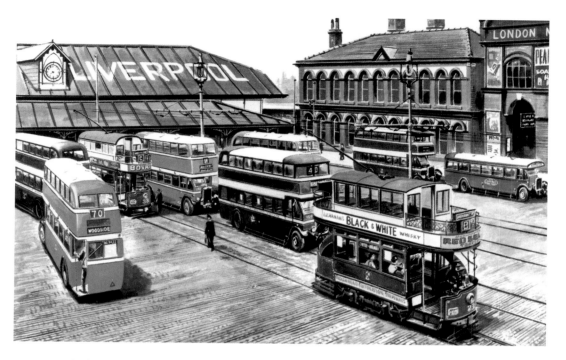

Woodside Bus Terminal.

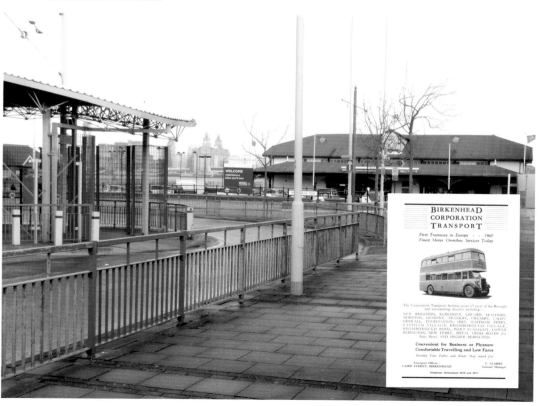

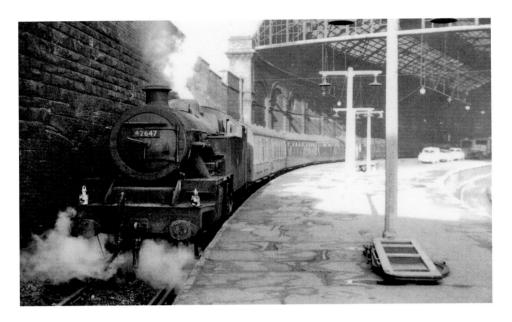

From Birkenhead to Paddington

Locomotive No. 42647 takes a Paddington-bound train from Birkenhead Woodside Station. The station was opened on 1 April 1878 and replaced Monks Ferry Station, which was the original terminus of the Birkenhead to Chester line. Work on the Chester & Birkenhead Railway began in 1838 and a single line was opened in September 1840. The Birkenhead terminal was built in Grange Lane, which was an equal distance from Woodside, Monks Ferry and Birkenhead ferries. Woodside Station survived until 6 November 1967, when it was closed. A section of the site is now a car park.

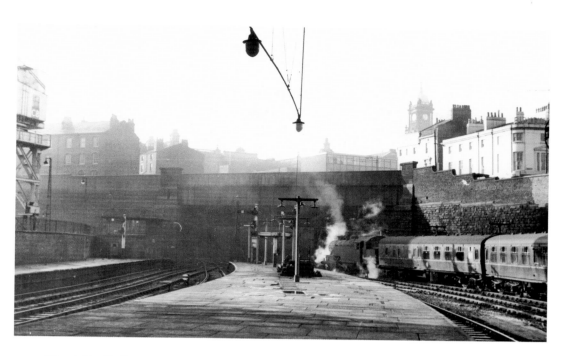

Woodside Station

A train enters the tunnel at Birkenhead Woodside Station in 1964. The Town Hall and the Birkenhead Police Headquarters can be seen behind the bridge. The Police Headquarters in Chester Street was opened in 1953 and an extension was added in 1956.

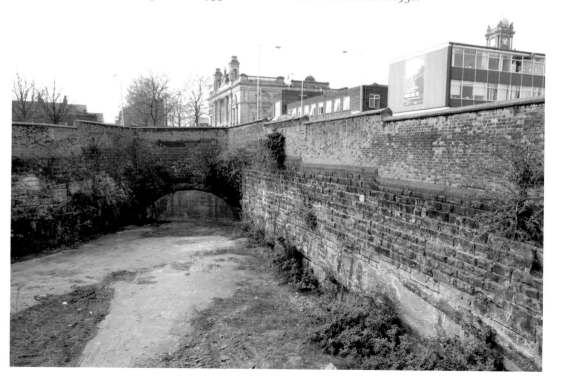

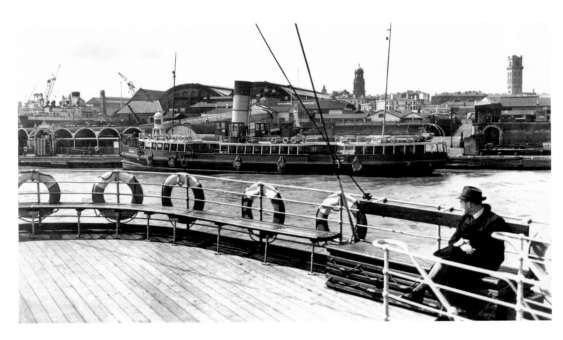

By Ferry to Birkenhead

A Birkenhead Corporation ferry from Liverpool sails past the *Bidston*, which is berthed at Woodside Landing Stage. Vessels under repair can be seen to the left of the landing stage in the yard of Grayson, Rollo & Clover Ltd.

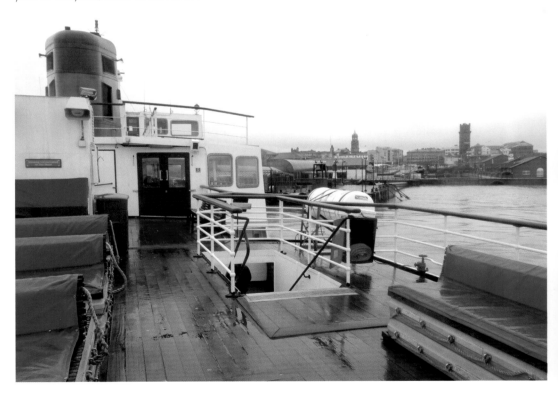

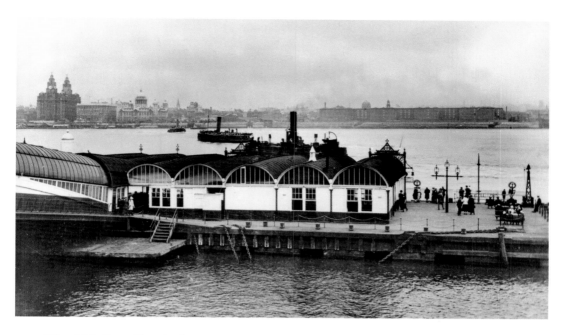

Woodside Ferry Terminal

Woodside Ferry Terminal in 1933. The floating stage was installed in 1862 and a floating roadway was built six years later to enable vehicles to travel across the river. However, the service had difficulty coping with the increasing demand in the early years of the twentieth century and it was announced that a vehicle tunnel would be built under the river. The Mersey Tunnel opened in 1934 and the vehicle ferry service was closed in 1939.

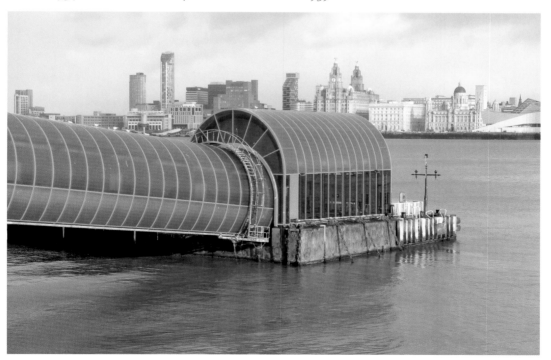

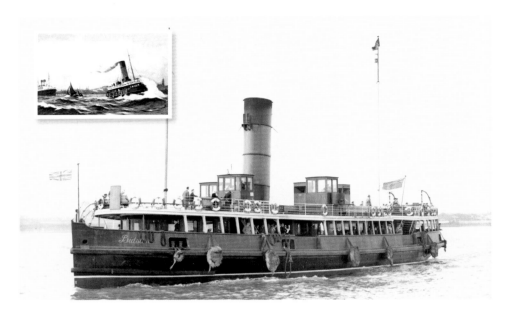

The Birkenhead Ferries

Birkenhead ferries *Bidston* and *Royal Daffodil*. *Bidston* was built in 1933 by Cammell Laird at a cost of £40,675 and joined her near sisters *Hinderton, Thurstaston,* and *Claughton* on the ferry services from the Wirral to Liverpool. On delivery of the new *Mountwood* and *Woodchurch*, she became surplus and was chartered to the Harbour Commissioners at Cork in 1960–61. She was broken up there in 1962. *Royal Daffodil* was built as *Overchurch* by Cammell Laird at Birkenhead in 1962 and was renamed *Royal Daffodil* in 1999. She is a unit of the present fleet of Mersey ferries.

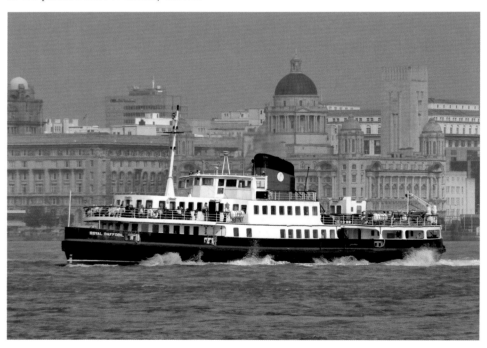

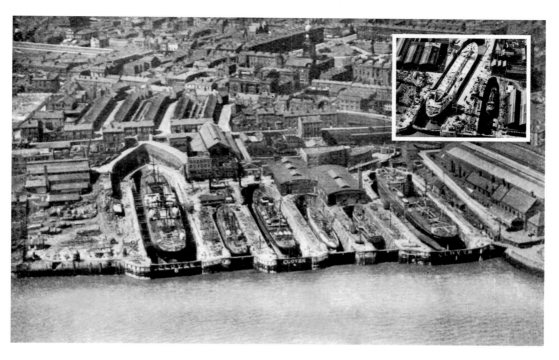

Dry Docks at Cammell Laird
Vessels in dry dock at Cammell Laird's yard. All of the dry docks in the photograph have been filled in over the years and housing and apartments have been built on the riverfront.

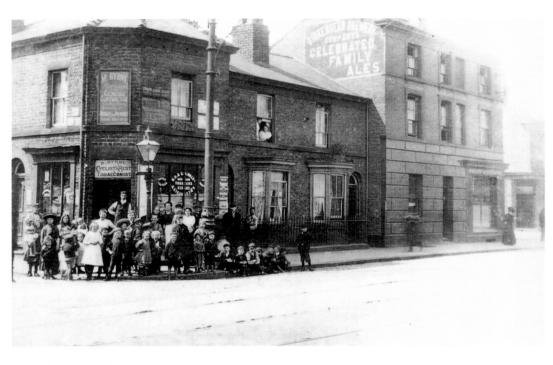

New Chester Road

M. Byrne 'Cyclist's Rest' Tobacconist, next to the Lord Raglan Hotel at 228 New Chester Road, in 1909.

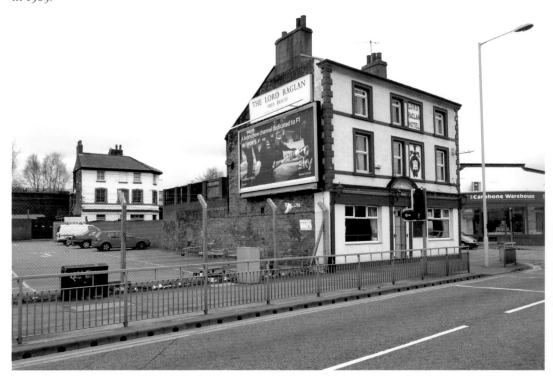

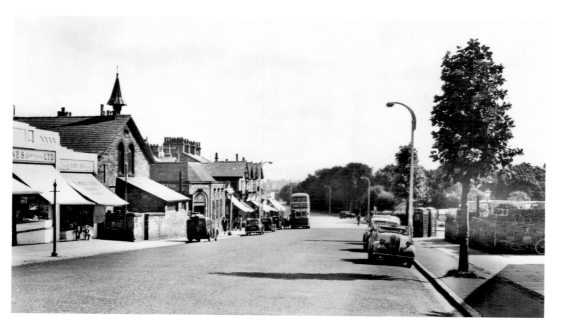

Upton Road, Claughton

Looking down Upton Road at Claughton Village towards Birkenhead. The stationery and tobacconists' shop was owned by Miss Harriet Bedford, who was also the sub-post mistress. St Bede's Mission Church was originally the Claughton Mission Room until it became the church and school in 1887. The school was transferred to Bidston Avenue in 1921.

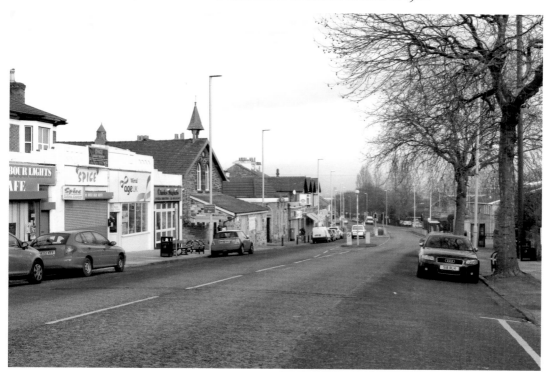

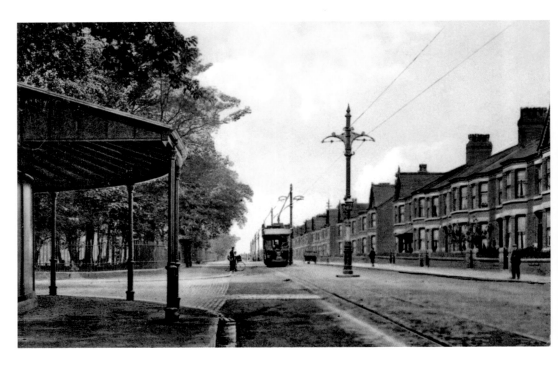

Park Road North
Park Road North in 1909. One of the first tram routes in the town was built along Park Road North.

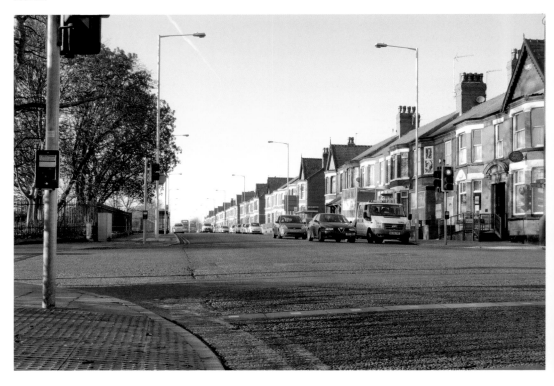

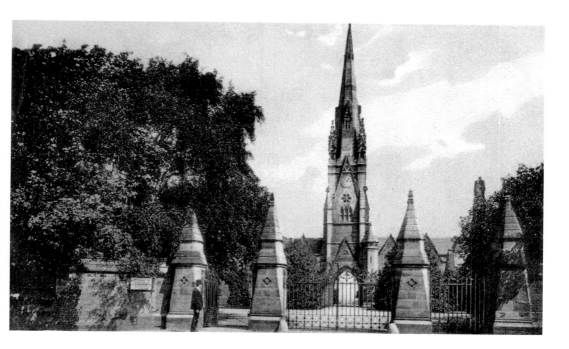

Flaybrick Cemetery

Flaybrick Cemetery was built by the Birkenhead Improvement Commissioners between 1862 and 1864 on Flaybrick Quarry. It was opened on 30 May 1864 and named Birkenhead Cemetery. It had three separate denominational chapels. The Roman Catholic chapel was demolished in 1971 and a memorial wall has been erected on its site. The Nonconformist and Church of England chapels were last used in 1975. Most of the buildings are now in a state of dereliction and the Registrar's office and Sexton's Lodge are now privately owned. Flaybrick Cemetery was renamed Flaybrick Memorial Gardens in 1995 and an arboretum has been created.

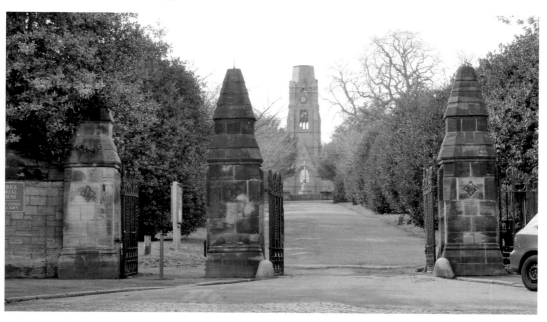

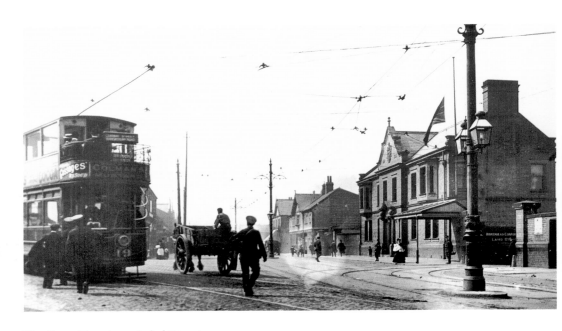

The Tram Terminus, Laird Street

Laird Street Tram Terminus in 1910. The Tramways Office was opened on 28 July 1903 following the introduction of the new electric trams and various routes across the Borough. Forty-two trams could be stored at the depot and this was later extended to accommodate sixty vehicles. An extension was built in 1927 when the new buses were introduced and the depot is still used as the depot for Arriva plc, Wirral.

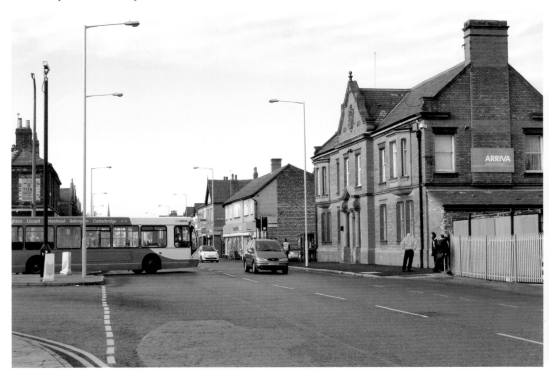

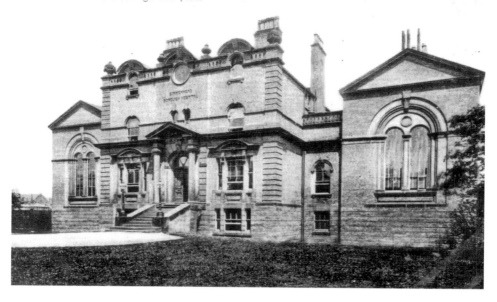

Birkenhead General Hospital

The foundation stone for Birkenhead General Hospital in Park Road North was laid on 24 November 1862, and it was opened in 1864 as Birkenhead Borough Hospital. It was built with contributions from John Laird on land donated by Thomas Brassey and replaced Birkenhead Hospital and Dispensary. The hospital consisted of four wards, three male and one female, and was designed with accommodation for fifty beds, an accident ward, operating theatre and board room. It became Birkenhead General Hospital in 1926 and was closed in 1982 when the new hospital at Arrowe Park was opened.

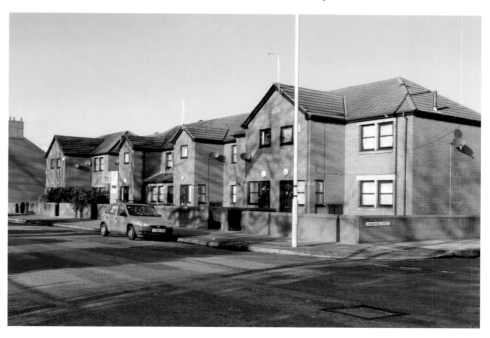

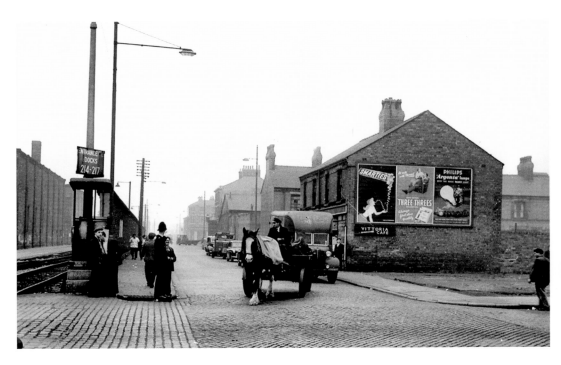

Vittoria Dock
A horse-drawn vehicle turns right into the main entrance to Vittoria Dock. Blue Funnel Line and Clan Line vessels loaded cargo in Vittoria Dock and sailed to the Far East, Japan, India and South African ports.

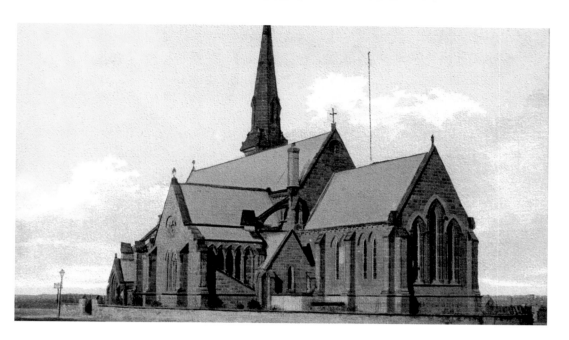

St James Church

St James Church in 1909. The church was built in 1858 and is located at the junction between Hoylake Road and Laird Street. It served a community housed in the Dock Cottages which were built by the Birkenhead Dock Company in 1845. The Cottages survived for over 100 years and were replaced by the Ilchester Square flats. The last unit of this complex were demolished in 2009.

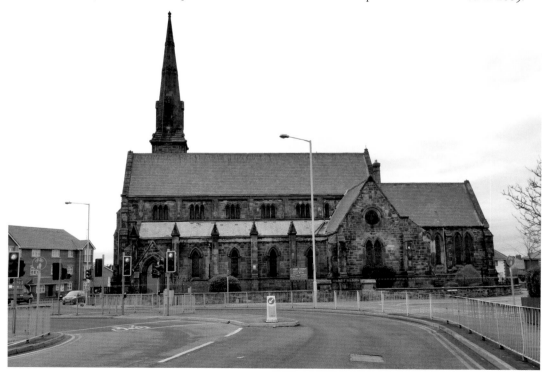

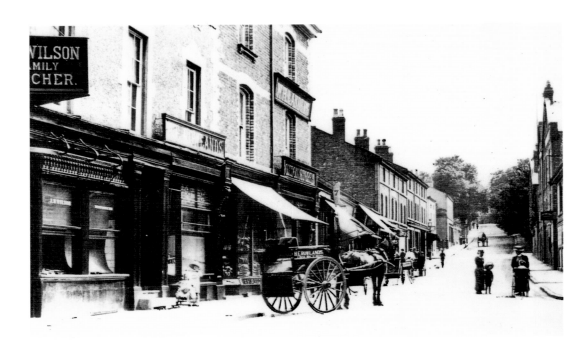

H. E. Rowlands, Rose Mount

H. E. Rowlands' poultry shop, delivery carriage parked outside the premises at Rose Mount, Oxton. The other shops are Arthur Rowlands, fruiterer; Selves, confectioner; J. S. Cooke, boot repairer; F. Tutty, ironmonger; Miss White, milliner; J. Fletcher, grocer; Bertha Young, draper; M. Crowhurst, confectioner; M. Jones, greengrocer; M. Wharton; E. Parker, newsagent; and C. Cameron, confectioner.

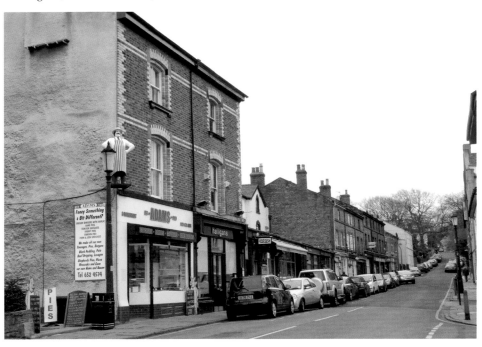

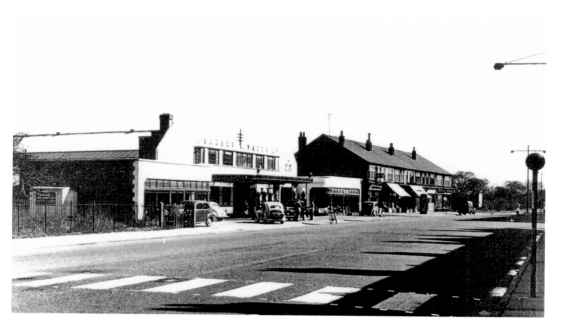

Hughes & Watts Garage

Hughes & Watts Garage in Woodchurch Road operated until the 1950s, when the premises were taken over by Kirby's Motor Engineers. The company sold the site to Sainsbury's, who built a supermarket which was opened in 1982.

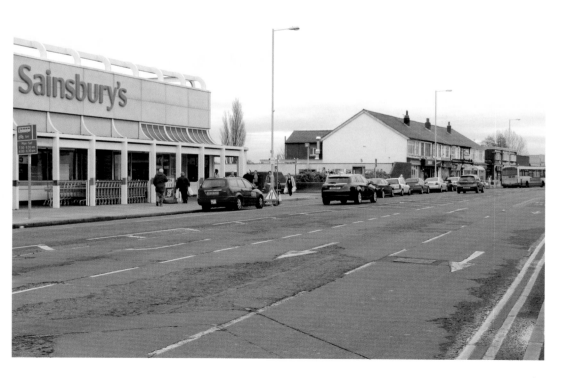

Wellington Road
Shops in Wellington Road, at the junction with Silverdale Road, Oxton, Birkenhead, in 1927.

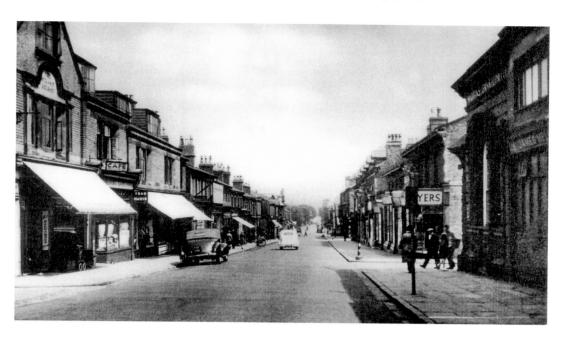

Bedford Road, Rock Ferry.

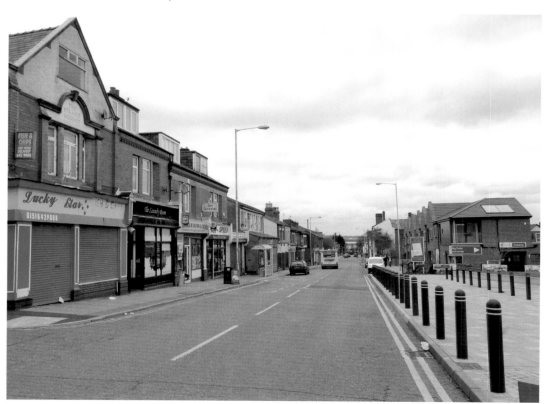

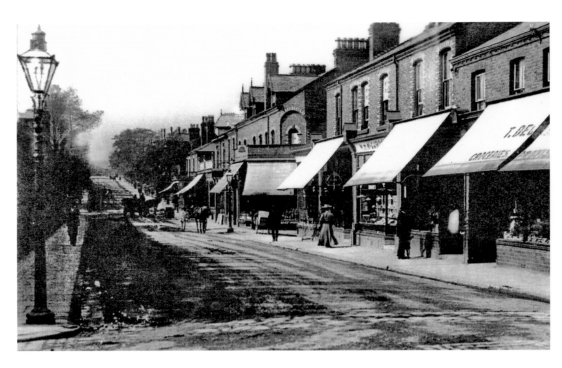

Bedford Road

Looking in the opposite direction up Bedford Road, Rock Ferry. The photograph is taken from outside Rock Ferry Merseyrail Station, which provides services to Liverpool and Chester.

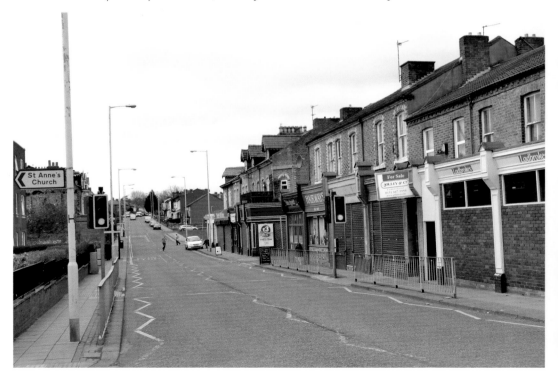

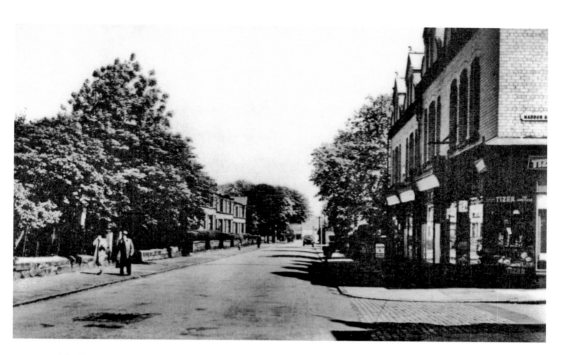

Bedford Road, Rock Ferry, looking down towards the River Mersey.

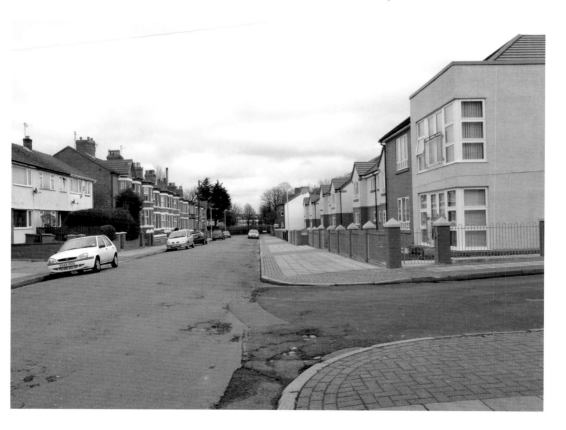

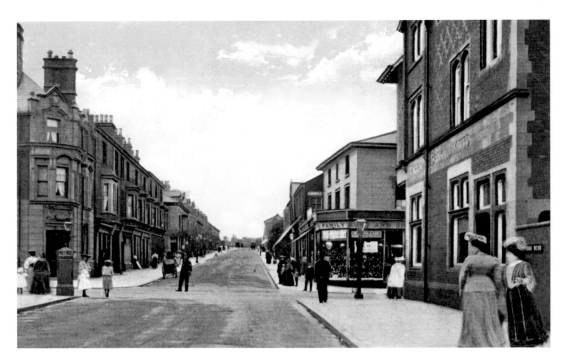

Rock Ferry

The junction of New Chester Road and Bedford Road in Rock Ferry in 1907. Bedford Road was once one of the busiest shopping areas in Rock Ferry but many of the banks and shops have now closed or have been transferred to offices in central Birkenhead.

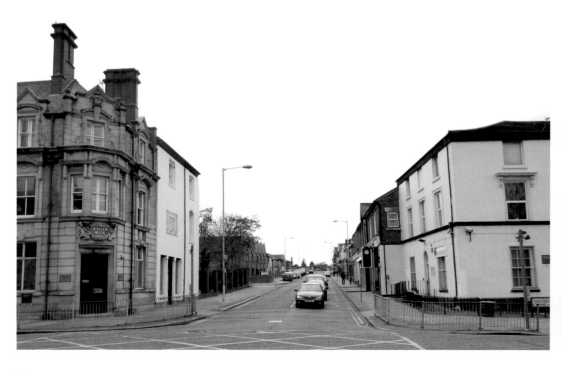

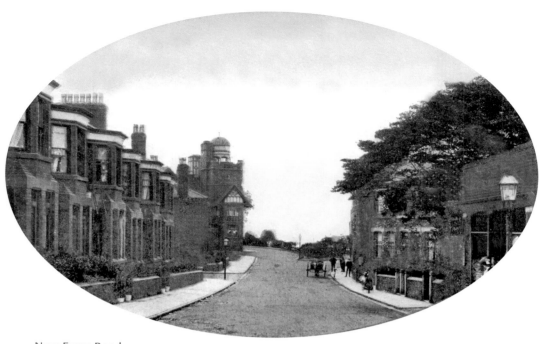

New Ferry Road
New Ferry Road leads to the River Mersey and was the main road to New Ferry Pier and the ferry service to Liverpool.

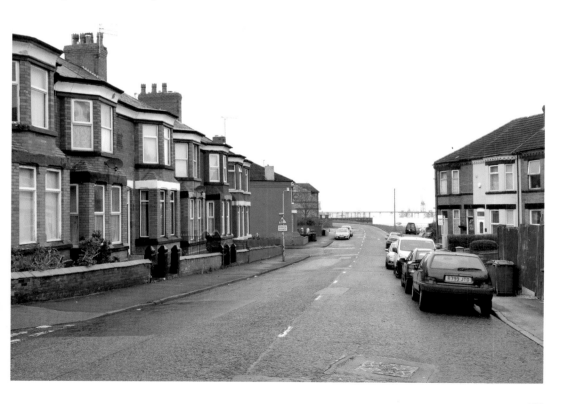

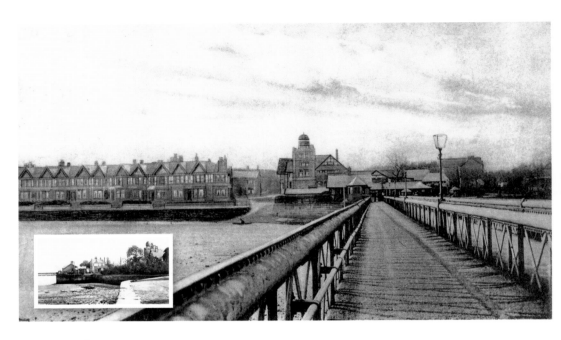

New Ferry Pier

The Toll Bar at New Ferry was the terminus for tram services from Birkenhead. The Pier at New Ferry was opened in 1865 and was 856 feet long. The ferry was initially operated by the Mersey River Steam Boat Company, who operated a service to Liverpool.

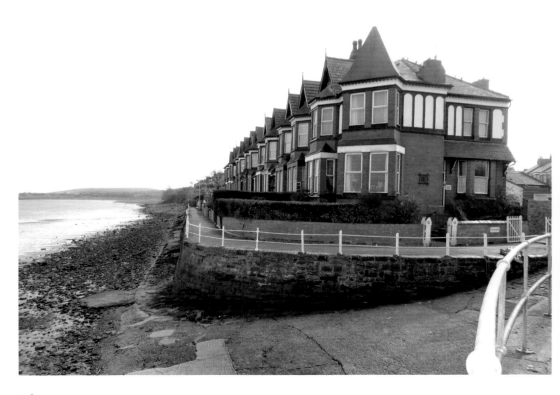

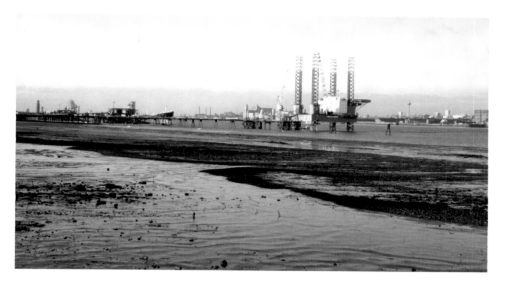

Tranmere Oil Terminal

The Tranmere Oil Terminal was inaugurated on 8 June 1960 with the arrival of the Shell tanker *Zenatia*, which discharged the initial cargo of crude oil. The oil facility was built to cater for the growing oil trade to the port as prior to this, petroleum, fuel oil and other refined products were discharged at the Dingle Tanker Buoy, where four moorings could accommodate tankers up to 18,000 tons deadweight. Crude oil is pumped ashore at Tranmere and transferred through a 15-mile pipeline to storage facilities at the Stanlow Refinery in Cheshire. The Terminal's first 200,000-ton tanker, *Melo*, arrived on 21 February 1970. She had been lightened, with some of her cargo being discharged into a smaller vessel to enable her to navigate the channel and the River Mersey. The tanker *Nisa*, of 322,912 tons deadweight, discharged her cargo in 1988 at Tranmere.

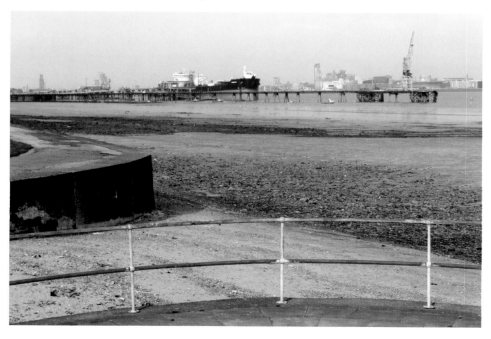

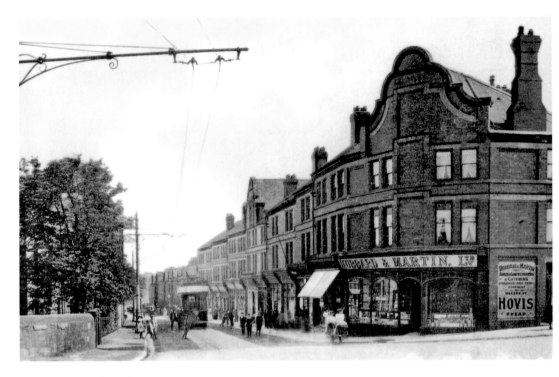

Bebington Road, Higher Tranmere.

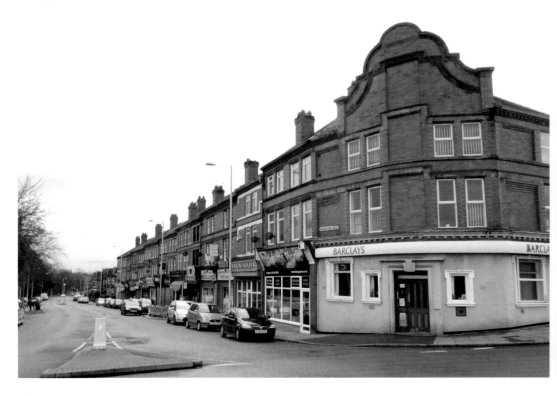

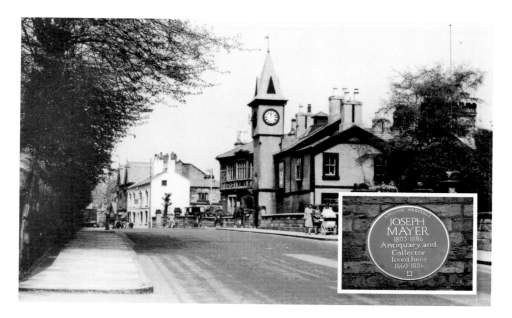

The Mayer Library

The Mayer Library in Lower Bebington in 1940. Joseph Mayer, the son of Samuel Mayer, tanner and currier, was born at Newcastle under Lyme on 23 February 1803. He moved to Liverpool in 1823 and set up as a jeweller and goldsmith. This enabled him to pursue his hobby of collecting Greek coins, later glass and pottery, antiquities, gems and rings, enamels, miniatures, metal work, drawings and engravings. He was a founder of the Historic Society of Lancashire and Cheshire and contributed papers to many publications. By 1860 he was benefactor to the village of Bebington and in 1866 he established a free library of 20,000 volumes at his expense. Mayer retired in 1873 and died at Bebington on 19 January 1886, aged 82.

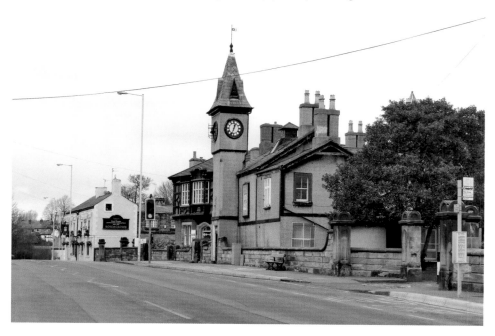

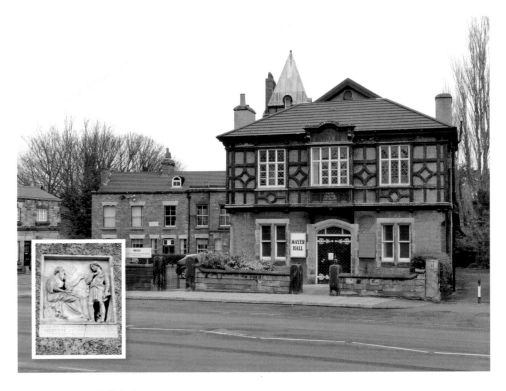

Above: Meyer Hall, Bebington.

Below: Birkenhead and Wirral Licensed Victuallers on the Green at Bromborough in September, 1928.

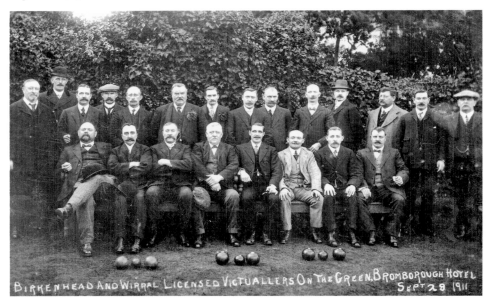

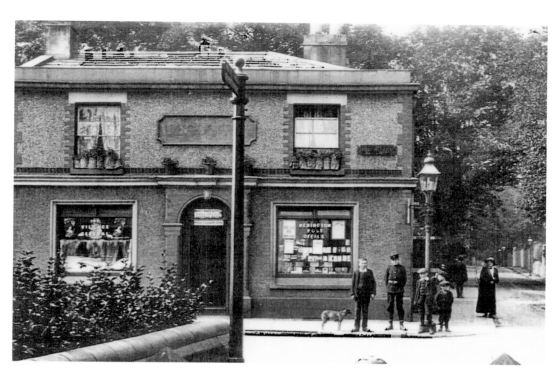

Bebington Post Office
Bebington Post Office in 1913. Although the building is now a private residence, the original public footpath sign remains.

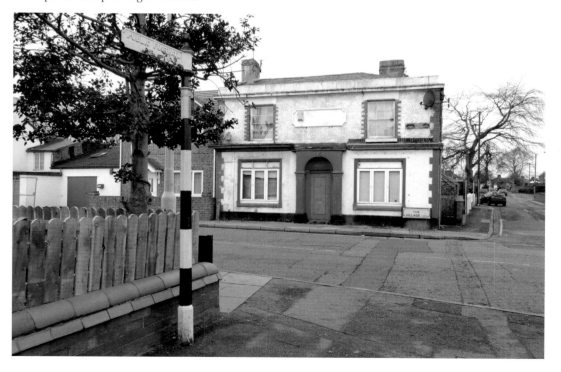

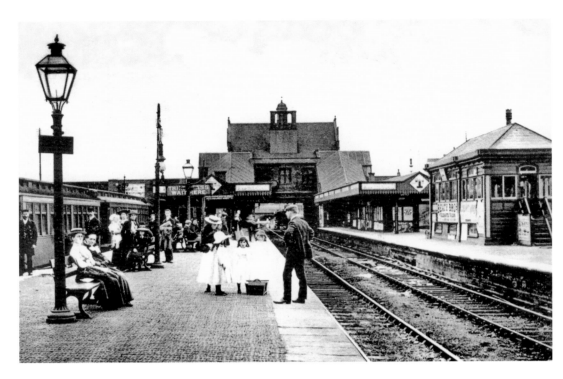

Park Station

Park Station *c.* 1930. The station entrance and building was destroyed in 1941 when the whole area, with its proximity to Birkenhead Docks, was a target for German bombers. The platform signal box was demolished in 1988 when the track signalling system on the Mersey Railway network was restructured.

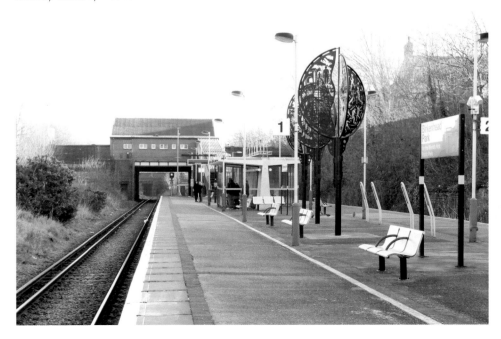

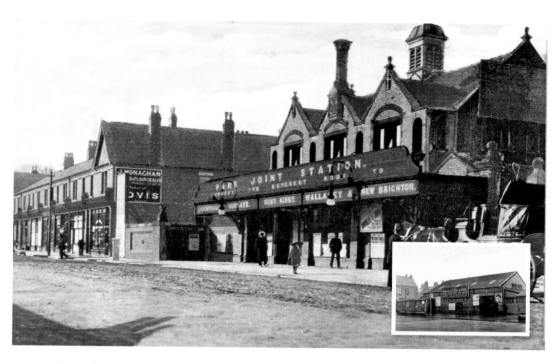

Park Station
Birkenhead Park Station in Duke Street was opened on 2 January 1888.

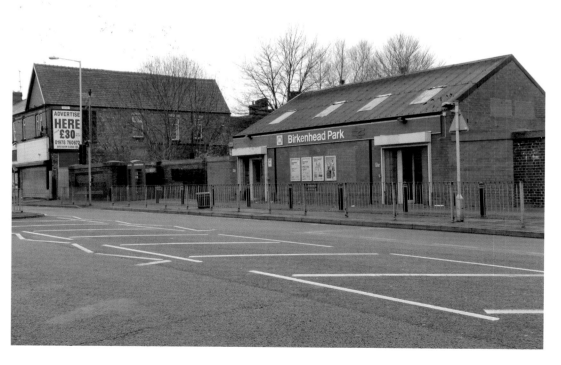

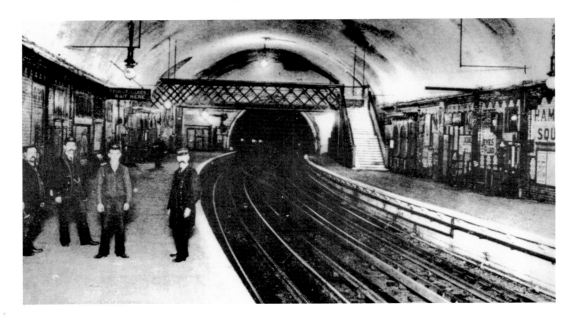

Hamilton Square Station in 1910.

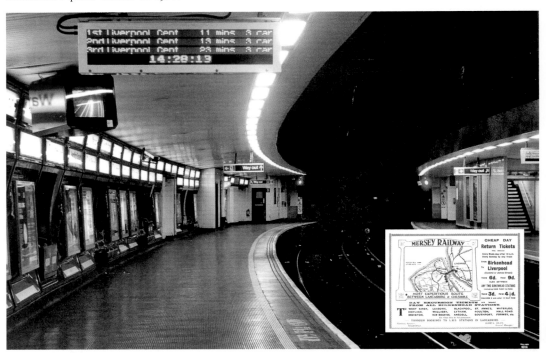

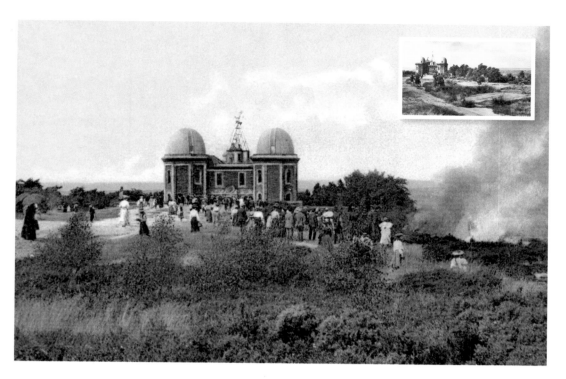

Bidston Hill

A bush fire on Bidston Hill in 1906. The land was originally part of Lord Vyner's estate and was purchased by Birkenhead Corporation in 1894. The windmill replaced a wooden mill that was destroyed by fire in 1791, and was used to grind wheat until about 1875. It is thought that there has been a windmill on this site since 1596 and after falling into disuse it was bought and restored in 1894.

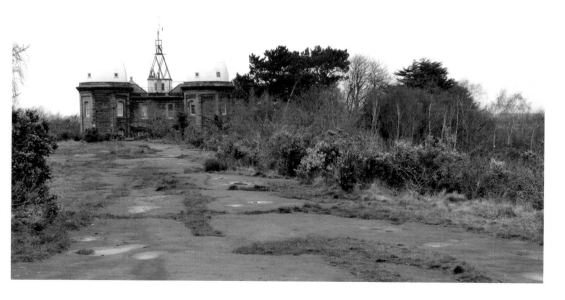

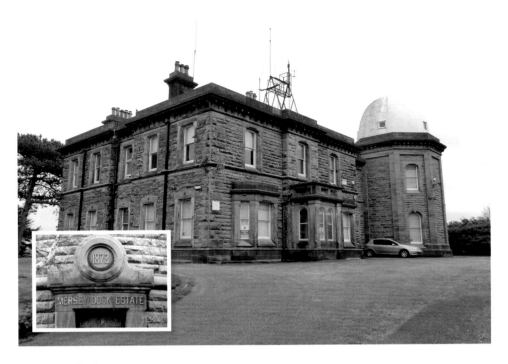

Bidston Hill Observatory

The Observatory and Tower on Bidston Hill. The Observatory was the home of the Institute of Coastal Oceanography and Tides, which was founded in 1843. The Observatory was transferred to Bidston in 1864 and astronomical and meteorological observations were continued under the Mersey Docks & Harbour Board. The lighthouse operated from 1873 to 1913. In 2003 the Institute moved to the main campus at Liverpool University and the buildings at Bidston Hill were advertised for sale.

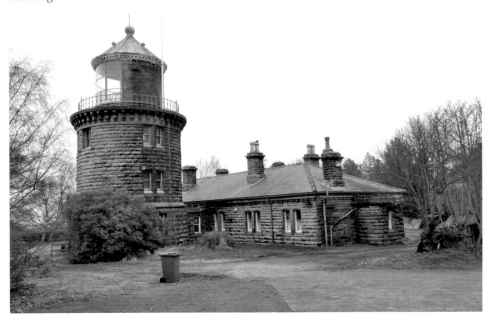

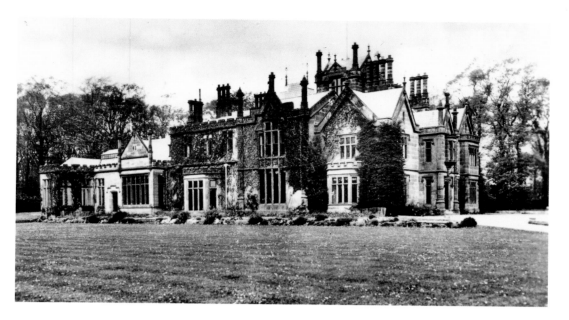

Arrowe Park Hall

The Hall at Arrowe Park was built for John Ralph Shaw in 1835 and was extended in 1844. It was used as a military hospital during the First World War. In August 1926 it was purchased, with additional land from Lord Leverhulme, by Birkenhead Corporation and became the home of the World Boy Scout Jamboree three years later. Arrowe Park was later opened to the public and the house was again used as a military hospital in the Second World War.

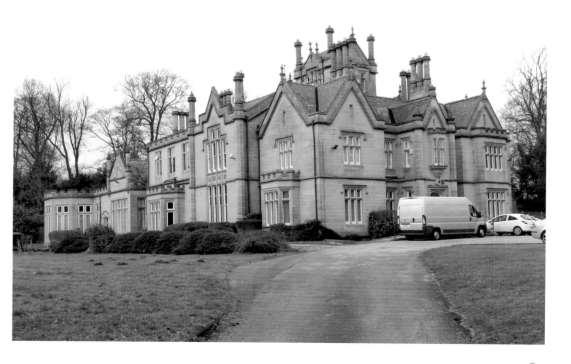

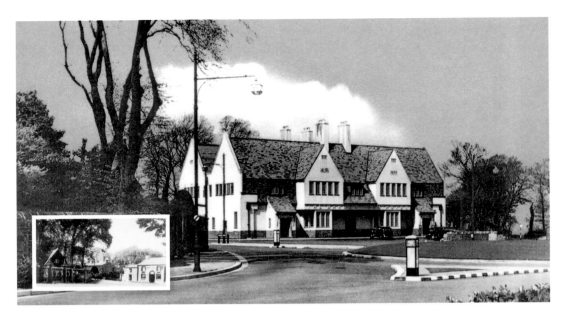

Arrowe Park Hotel
The Arrowe Park Hotel was opened in 1937 and replaced the Horse and Jockey Inn.

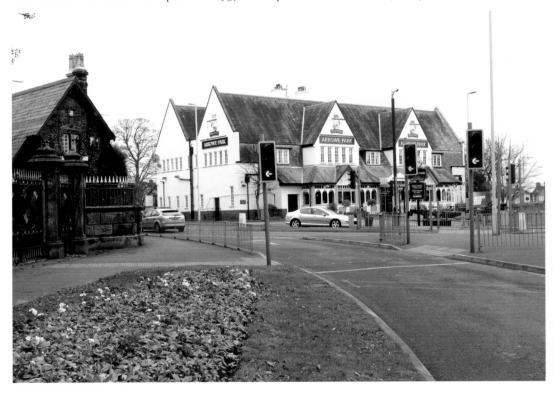

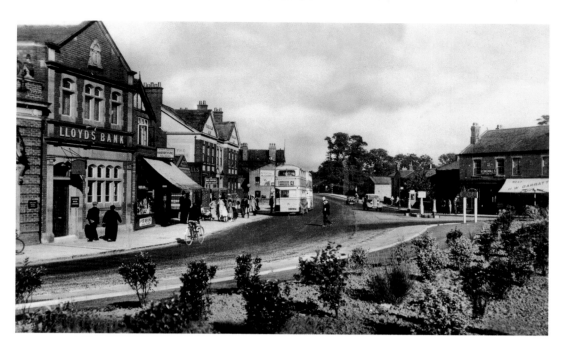

Moreton Cross

Moreton Cross and Birkenhead Road at Moreton in 1950. Moreton is protected from the Irish Sea by a long concrete embankment that was built between Meols and Leasowe, and the North Wirral Coastal Park also runs for 4 miles along the coast. It is also the home of food manufacturing companies and has a drug development and research laboratory owned by Bristol-Myers Squibb.

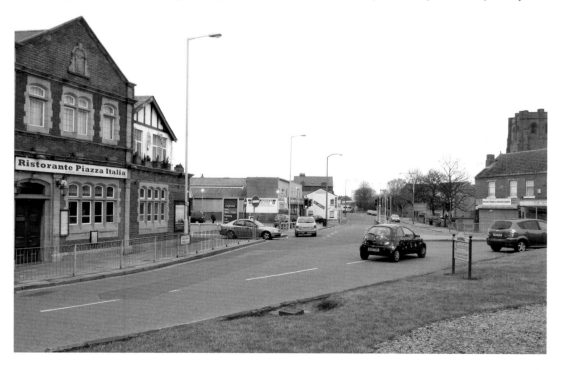

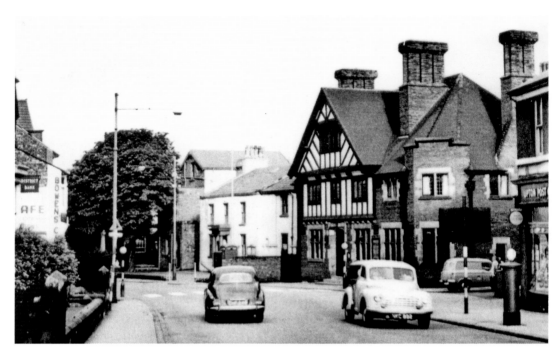

Upton Village

Upton Village, looking towards Birkenhead. In the middle of the nineteenth century a weekly market was held at Upton; fairs were held twice a year, on the last Friday in April and on the Friday before Michaelmas. The town became part of the County Borough of Birkenhead in 1933.

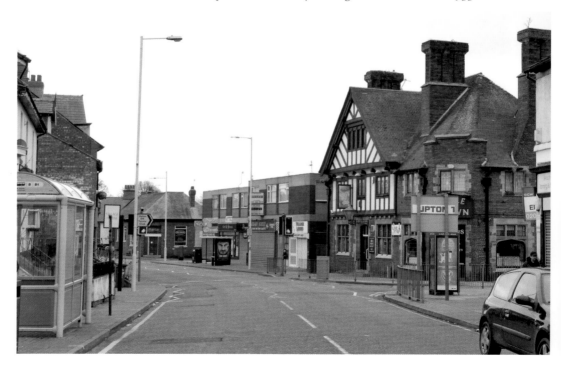

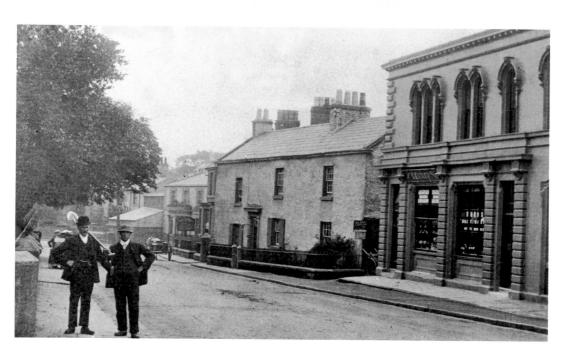

Upton Village.

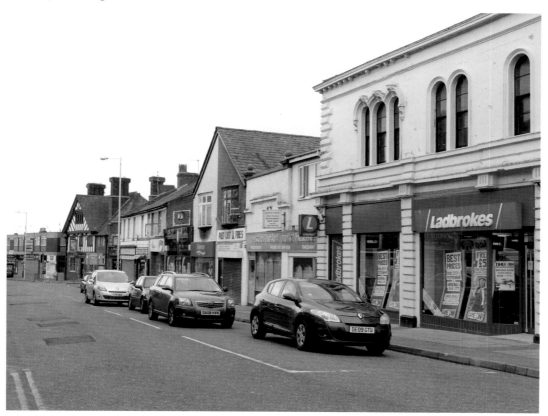

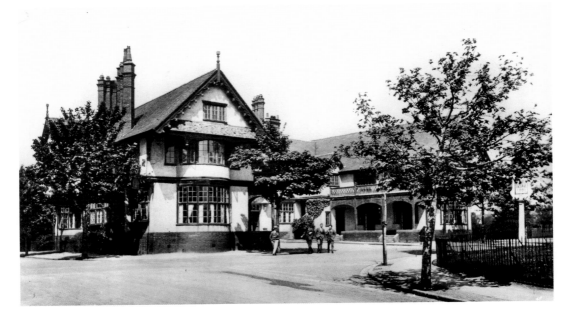

Bridge Inn, Port Sunlight

The Bridge Inn at Port Sunlight. The hotel was built in 1900 and is a Grade II Listed building with features such as the original wood panelling and a stained glass dome room in the bar. It was originally a temperence hall, following William Hesketh Lever's belief in abstinence. It became licensed by 1903 and was designed according to a concept of the ancient English hostelry, with dining, tea and assembly rooms.

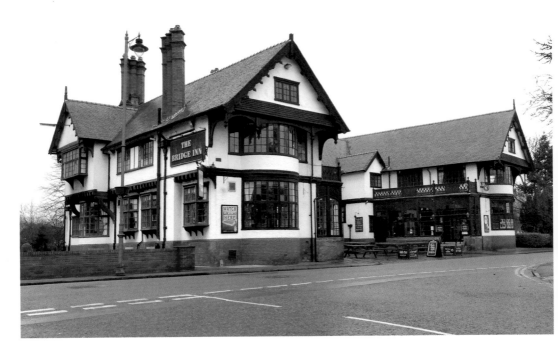

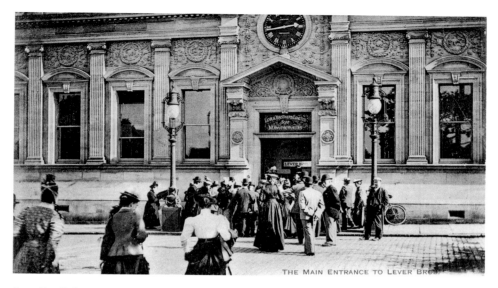

THE MAIN ENTRANCE TO LEVER BROS

Port Sunlight

Port Sunlight was chosen by William Lever as it was ideally placed, with its road, rail and water links. The first factory was opened in 1889, followed by the construction of the first cottages two years later, and the original village was completed by 1897.

Lever had completed 890 houses at Port Sunlight at the time of his death in 1925 and was responsible for the construction and provision of a number of important community buildings. Gladstone Hall, Hulme Hall, the Bridge Inn, the Gymnasium, Open Air Swimming Bath, the Girls' Club and Cottage Hospital and other community-based facilities were provided for the use of people living in the village. Christ Church was built and the Lady Lever Art Gallery was completed in 1922. It was opened by Princess Beatrice and the Prince of Wales (later King Edward VIII) visited in 1931 and the Duke of York (later King George VI) opened a group of cottages which bear his name in 1934. The village was declared a Conservation Area in 1978 and in 1980 the houses became available for the tenants to purchase.

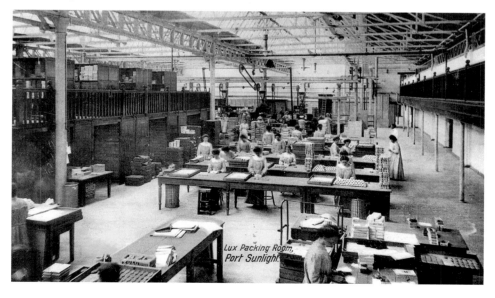

Lux Packing Room, Port Sunlight.

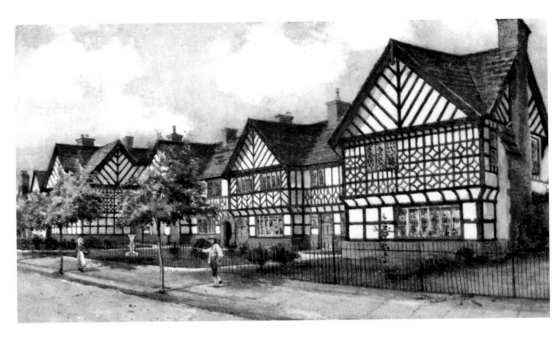

Port Sunlight
Cottage Homes, Greendale Road, Port Sunlight in 1910.

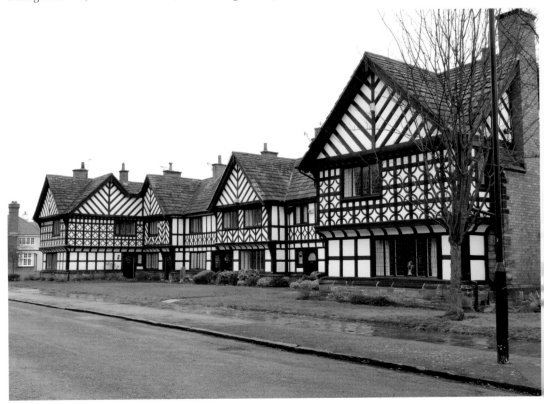

St Oswald's Church, Bidston
St Oswald's Church in Bidston Church from School Lane. A church has stood on this ground since the twelfth century and parts of the present church date back to the sixteenth century. It was rebuilt in 1856 and a sanctuary was added in 1882. One of the bells has the inscription 'St Oswald', and it is thought that it came from St Oswald's Church in Chester.

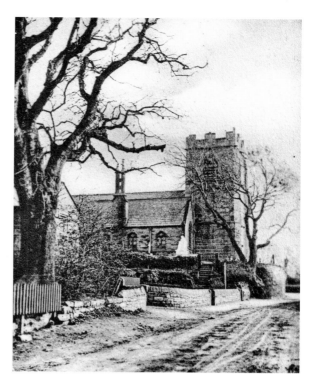

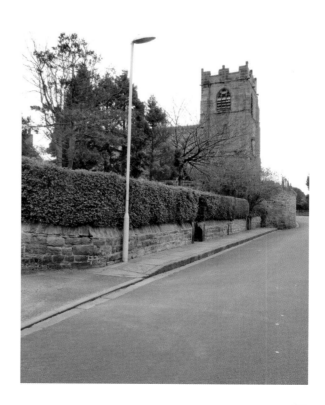

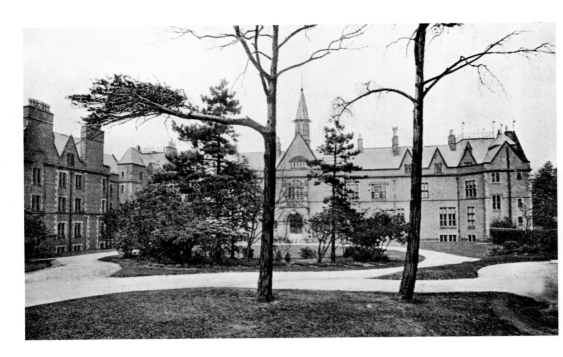

St Aidan's College

St Aidan's College was founded in 1846 by Revd Joseph Baylee and the college opened the following year in Cambridge Terrace, Slatey Road. A purpose-built college was built with the aim of preparing men for the ministry of the Church of England. The college maintained close links with Christ Church, which was one of the churches used by the college in the training of ordinands. Students were attached to the church and they preached and assisted in various activities. When Christ Church was struck by lightning in 1924, St Aidan's allowed them to use the college chapel for worship in Sundays. The college occupied six acres of land between Shrewsbury Road and Forest Road and the main buildings were completed in 1856. It survived until 1969, when it was demolished.